MOUNT ASSINIBOINE

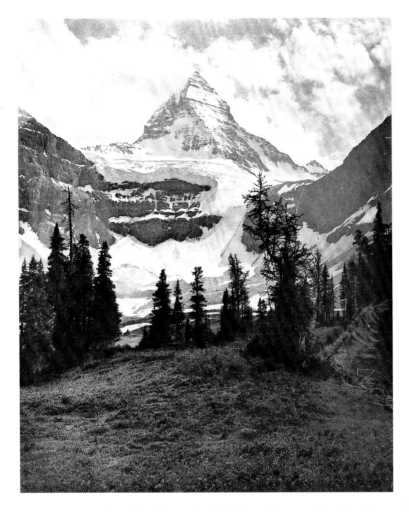

WALTER WILCOX, Mount Assiniboine, 1899 (?). Whyte Museum of the Canadian Rockies (v85/na66-573).

MOUNT ASSINIBOINE

Images in Art

JANE LYTTON GOOCH

PREFACE BY ROBERT SANDFORD

Rocky
Mountain Books

VANCOUVER • VICTORIA • CALGARY

Rocky Mountain Books
#108 – 17665 66A Avenue
Surrey, BC V3S 2A7
www.rmbooks.com

Rocky Mountain Books
PO Box 468
Custer, WA
98240-0468

LIBRARY AND ARCHIVES CANADA CATALOGUING IN PUBLICATION
Gooch, Jane Lytton
Mount Assiniboine: images in art/Jane Lytton Gooch; preface by Bob Sandford.

Includes bibliographical references and index.
ISBN 978-1-894765-97-8

1. Assiniboine, Mount, Region (Alta. and B.C.)—Pictorial works.
2. Assiniboine, Mount, Region (Alta. and B.C.)—In art. I. Title.

N8217.A88G66 2007 971.1'65 C2007-902916-7

Library of Congress Control Number: 2007931972

Edited and proofread by Joe Wilderson
Book and cover design by Frances Hunter
Front cover painting is Zelda Nelson's Mount Assiniboine, from the private collection of Catherine Goulet and Michael Harris. Back cover image is Glen Boles' Mount Assiniboine, 1995, from the private collection of Glen Boles.
Quotations from the poems "Bushed" and "David" are drawn from *One Muddy Hand: Selected Poems by Earle Birney*. Sam Solecki, ed. Madeira Park, B.C.: Harbour Publishing, 2006.

Printed and bound in Hong Kong

Rocky Mountain Books acknowledges the financial support for its publishing program from the Government of Canada through the Book Publishing Industry Development Program (BPIDP), Canada Council for the Arts, and the province of British Columbia through the British Columbia Arts Council and the Book Publishing Tax Credit.

The Canada Council | Le Conseil des Arts
for the Arts | du Canada

BRITISH COLUMBIA
ARTS COUNCIL
We acknowledge the support of the Province of British Columbia through the British Columbia Arts Council

ACKNOWLEDGEMENTS

I want to thank the many people who have generously offered their assistance and moral support. My family and friends have given me constant encouragement. My husband, Bryan, has helped me at every stage, including proofreading. My sons, Arthur and Robert, have offered technical advice, and Robert has hiked with me on the Assiniboine trails. Bob Sandford suggested I explore the art of Mount Assiniboine after the completion of the O'Hara book, and he has provided continued support. Barb and Sepp Renner welcomed me to Mount Assiniboine Lodge and advised me on artists' perspectives. Roy Andersen has enthusiastically given his time to photograph contemporary paintings. The artists' images are my inspiration, but without the special interest and cooperation of the owners of the paintings, the holders of copyright, and the artists, my work would not have been possible.

Several other people provided valuable help along the way. Pat Dearden determined the likely vantage point of Barbara Leighton for *Lunette Peak* and of Herb Ashley for *Marvel Lake* and with his wife, Ellen, climbed The Towers to take reference photographs for my research. Jon Whelan suggested sources of Banff history; Dr. Ronald Hatch put me in touch with Joe Plaskett; David McEown pointed me in the direction of the Royal Ontario Museum; Tim Wake arranged for the photograph of Mike Svob's *The Towers*; Frances Schwenger, the daughter of Frank Panabaker, told me about her father's book *Reflected Lights*; Glen Boles suggested A.C. Leighton's perspective in his elevated view of Mount Assiniboine; and Alice Saltiel-Marshall and her husband, Bill, helped me overcome some difficult obstacles.

I have received assistance from libraries, galleries, and museums, including D. Vanessa Kam, University of British Columbia Fine Arts Library; Ann Macklen, University of British Columbia Press; Andrea Dixon and Sylvie Roy, National Gallery of Canada; Nicola Woods and Stephanie Gibson, Royal Ontario Museum; Leslie Green, Smithsonian American Art Museum; Pamela Clark, Art Gallery of Alberta; Paula Swann, Leighton Art Centre; Masters Gallery, Calgary; Diana Paul Galleries, Calgary; Lois Corey, Fieldcote Memorial Park & Museum, Ancaster, Ontario; Steve Westley, Centre for Topographic Reproduction, Ottawa; Martine Couture, The Atlas of Canada; Jim Bowman, Glenbow Archives; Quyen Hoang, Jacqueline Eliasson, and Johanna Plant, Glenbow Museum; Ted Hart, Elizabeth Kundert-Cameron, and Lena Goon, Whyte Museum Archives; and Joanne Gruenberg, Craig Richards, and D. L. Cameron, Whyte Museum. Travel grants from the University of British Columbia in April 2004 and May 2005 helped to cover the cost of my research in Calgary and Banff.

Finally, my special thanks go to Don Gorman of Rocky Mountain Books for his cheerful guidance through the publication process.

DEDICATION

"To all who find inspiration in the mountains"

Contents

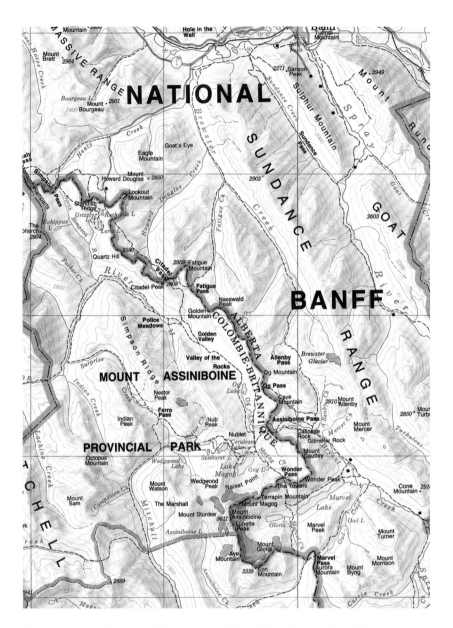

Map based on portion of Banff, Kootenay and Yoho National Parks, *Atlas of Canada*, MCR 220 (Ottawa: Department of Energy, Mines and Resources, 1985), reproduced by permission.

Preface

EVEN IN A MONUMENTAL LANDSCAPE like the Canadian Rockies there are places where it seems the natural glory of the Canadian West is somehow more intensely concentrated than elsewhere. It is to these places that generations of adventurers and artists have unfailingly gravitated. It is in such places that the legend of our western mountain parks was born.

In her book, *Artists of the Rockies*, Jane Gooch wrote about one of these "power places," which happened to be located in Yoho National Park. *Artists of the Rockies* illustrated the works of a century of painters who were inspired not just by the scenery but by the sense of place that pervaded every aspect of their experience of Yoho's remarkable Lake O'Hara. Dr. Gooch then went on to observe that, though it shares some of the same arresting themes of scale and grandeur, Lake O'Hara is very different from other famous power centres in the Rocky Mountains. In order to appreciate the unique challenges artists face in interpreting the subtleties of place in this great mountain chain, it is worth considering how the elements that compose a sense of place at Lake O'Hara differ from those that contribute to the unique character of a similarly engaging place like Mount Assiniboine.

Tucked beneath the Great Divide separating Alberta from British Columbia, Lake O'Hara is the centre of a grand landscape that radiates outward from its shores to create a mountain paradise defined by common rock types, lake reflections of enormous peaks, and local weather patterns which are expressed in a uniquely local complex of vegetation. All of these features are presided over by the known presence of grizzly bears. The combination of these features imbues this concentrated area with signature qualities. As regular visitors will tell you, Lake O'Hara, quite literally, feels like and smells like no other place in the Rocky Mountains.

Lake O'Hara and Mount Assiniboine share similar elements of place. There are tall mountains in the Assiniboine area and beautiful lakes. The alpine meadows are as perfect as in any in the Rockies and the presence of the great bear here too ensures that visitors are kept at the same heightened level of awareness as they are at Lake O'Hara. But it is a noticeably different place. The reason for this is that all of these elements are eclipsed by the overwhelming presence of a single imposing wonder: Mount Assiniboine itself. One of the most stunning geological features on the continent, this great stone tower completely dominates the surrounding landscape. Even when unseen in darkness or in storm this peak exerts a powerful, a sometimes terrible presence that can press down upon those who stand beneath its sheer walls.

The staggering scale of this mountain makes it difficult to comprehend its full physical and aesthetic dimensions or to represent them in word or image. It can be argued that Mount Assiniboine is one of the few remaining famous places in the world that doesn't disappoint. It is invariably more beautiful than what even the best photographs portray, and its wonders remain layered in timeless nuance beyond what guidebooks have the capacity to describe. This same utter magnitude and mystery that puts Mount Assiniboine outside the capacity of photographs and ordinary descriptions to capture make this mountain an irresistible subject of poetry and art.

Single, solitary giants like Mount Assiniboine have made great demands on both poets and painters. What other mountain could Earle Birney have been describing in his great poem "Bushed," in which he wrote that lightning struck a rainbow and "shattered it into the lake-lap of a mountain / so big his mind slowed when he looked at it"? What other mountain could have inspired the conclusion of this same poem, in which Birney painted a literary picture of a man so overwhelmed by a mountain's solitude that he felt the winds "were shaping its peak to an arrowhead / poised" until

"...he could only / bar himself in and wait / for the great flint to come singing into his heart." In what other place but Mount Assiniboine could Birney find a peak—as he put it in his poem "David"— "...upthrust / Like a fist in a frozen ocean of rock that swirled / Into valleys the moon could be rolled in...."

If poets have been inspired by Mount Assiniboine, its attractions have made generations of artists positively giddy. As Jane Gooch illustrates, artists in each generation have succeeded in capturing certain elements of the larger reality of the peak and its surroundings. But even the best painters have had difficulty handling the scale of the mountain first-hand. The works that appear to have the greatest power are those that capture the breathtaking sense of being there. Artists that stayed to paint in the presence of the mountain, rather than painting later from wide-angle photographs, appear to have been more successful in capturing the relative scale of Assiniboine.

From this book we also learn that painters like Walter Phillips were able to go beyond scale to capture perfectly the nature of local rock and the unique circumstances of shadow-less local light. You can taste the wind and smell the larches in Carl Rungius's paintings. Jean Pilch, who pays special attention to tundra, captured the green surf lapping like a living tide at the base of the peak.

Though Assiniboine is stunning in any season, autumn is special. Some of the paintings in this book depict the extraordinarily clear, oblique light that sets fire to the yellowing larches while turning the sky cobalt, the waters silver and the great peak glittering white. Catharine Whyte accurately portrayed what the fall winds do to cloud on this great Matterhorn of a peak, and Peter Whyte certainly got winter right.

Perhaps not surprisingly, some of the most striking works in this book are those that portray the peak in turbulent weather. Clear blue skies are precious in the Rockies. This is a land of rock, ice and cloud. Mount Assiniboine is so large it creates its own storms. Lightning loves this peak. As Glen Boles and Alice Saltiel-Marshall illustrate, weather is its métier.

Images such as these penetrate deeply like memories. Like the experience of the place itself, these images possess more than our senses can hold. They enter our eyes, our minds and even our tissues, from which they percolate into our hearts. It only takes a brief time in such places and in the presence of such art before one confronts the eternal. In the presence of the timeless, many of the things we are doing as a society in our time make little sense.

The paintings in this book prove that, though some artists have come very close in their time, the definitive work depicting Mount Assiniboine has yet to be painted and probably never will be. The story is of this place, and the art that portrays it is not over. This is as it should be, for the true essence of this great peak and its surroundings creates itself anew for each generation. The self-regenerating nature of the Mount Assiniboine landscape should serve as ongoing inspiration for every person, now and in the future, who would set out to discover themselves by exploring our mountain parks.

In such a context this collection has the potential to be much more than just another art book. In the right hands it could serve as a trail guide of a higher order pointing the way ultimately to forms of art which, like the mountains themselves, invite us to struggle ever upward toward the light.

In times such as ours we need such guides.

Robert William Sandford
Canmore, Alberta, July 2007

Introduction

NOWADAYS MOUNT ASSINIBOINE can be approached effortlessly by helicopter. As the modern tourist swoops around the rocky chimneys in Assiniboine Pass, the mountain suddenly fills the landscape, rising 1475 metres from the reflecting water of Lake Magog to its astounding summit. One gazes in amazement at the symmetry of this magnificent pyramid towering over the glacier and the lake, as the helicopter gently descends, bringing its passengers to the broad alpine meadows just north of Lake Magog. This wonder on first seeing Mount Assiniboine recreates the first impressions of the early explorers, particularly Walter Wilcox, the mountain's earliest photographer, who, in 1895, approached from the other side, the southwest, arduously coaxing horses through burnt timber in the Mitchell River valley and climbing to Cerulean Lake and, finally, to Sunburst Lake (or Summit Lake as he called it), where Wilcox and his party suddenly saw Mount Assiniboine:

> … a most majestic spire or wedge of rock rising out of great snow fields… It would be impossible to describe our feelings at this sight, which at length, after several days of severe marching, now suddenly burst up on our view. The shouts of our men, together with the excitement and pleasure depicted in every face, were sufficient evidence of our impressions.[1]

Wilcox was the first to publish, in 1897, a description of the journey to the base of Assiniboine and the mountain itself, a 51-mile circuit accomplished in two days, accompanied by Bill Peyto and Robert L. Barrett, an American businessman and early sport climber. Wilcox's detailed account of the physical challenges in attaining the summit of such an awesome mountain—one which rises from a glacier amid a cluster of peaks on the Great Divide and towers over numerous lakes and alpine meadows below—intrigued members of the climbing community eagerly hoping for first ascents.

The name "Assiniboine" refers to the Stoney people, members of the Sioux nation, who would put hot rocks into water-filled holes in the ground, which were lined with skins, to bring the water to a boil. Hence, they were known as "stone-boilers," or Stoneys.[2] Barb Renner, who has managed Mount Assiniboine Lodge for over 20 years, offers the fanciful suggestion that the plume of cloud that streams from the peak in a west wind makes the mountain look like a huge boiling-stone.[3] Assiniboine, in fact, is so high that it does appear to create its own clouds as the air is suddenly forced upward and cooled.

Dr. G.M. Dawson named Assiniboine in 1885 while directing the Dominion Geological Survey. Historical accounts suggest he first saw the peak from a distance, from White Man's Pass to the east according to Walter Wilcox,[4] and from Copper Mountain west of Banff as early as 1884 as stated in Lillian Gest's history of Mount Assiniboine.[5]

Early Attempts on the Summit

BARRETT

Assiniboine's height and characteristic Matterhorn shape lured aspiring climbers to make a closer inspection. When Robert Barrett, a guest at the Banff Springs Hotel, inquired about sport climbing in August 1893, he was given the name of Tom Wilson, the guide for the Canadian Pacific Railway.[6] Wilson suggested Mount Assiniboine as an appropriate objective; he had heard about the mountain from Dr. Dawson, and he had seen it himself from Simpson Pass in 1889 while doing a topographical survey with W.S. Drewry[7] in order to open up the West along the newly completed CPR line. Wilson and Barrett were joined by Wilson's business partner, William Fear, who agreed to act as

cook. The climbing party's pack train set out in early September, up Healy Creek to Simpson Pass along Indian trails. They descended into the Simpson River valley and camped near where the south branch joins the Simpson. When they climbed a ridge to get a better sense of direction, Wilson and Barrett were overwhelmed by the awesome sight of the now much closer Mount Assiniboine.[8]

Barrett ascended the ridge again the next day and found a possible route up Surprise Creek in the next valley and over what we now know as Ferro Pass into the Mitchell River valley. Following the Mitchell River to its headwaters in Cerulean Lake, they easily passed Sunburst Lake and arrived at Assiniboine. But having reached the base of the mountain, they realized they were too late in the season for a climbing attempt. The party returned to the Simpson River and found their way home over Vermilion Pass, a much longer journey.[9] Though Assiniboine remained unclimbed, Wilson had pioneered the approach to the massive peak.

ALLEN AND CARRYER

In that summer of 1893, Samuel Allen, of Philadelphia, Pennsylvania, saw Mount Assiniboine from Mount Rundle.[10] He had been impatiently waiting for Walter Wilcox, a fellow student from Yale University, to arrive in Banff so they could go climbing together. The two men would eventually travel to Assiniboine separately, however, because after exploring around Lake Louise, Sentinel Valley, Valley of the Ten Peaks, and the Wenkchemna and Opabin Passes in the summer of 1894,[11] they had a disagreement about the map of the Lake Louise area.

Allen appears to have been the first of the two men to see Mount Assiniboine, in September of 1894. Accompanied by Yule Carryer, a student from Toronto, Allen bushwhacked along the Vermilion River until they came to the Simpson trail, allowing them to ascend the river valley as far as the third stream flowing from the east, according to Dr. Dawson's map. Like Wilson and Barrett the year before, they followed Surprise Creek, hoping to discover Mount Assiniboine to the east. Allen has left a fascinating account of this journey in *The Alpine Journal*[12] in which he reveals his great sensitivity to the alpine landscape. Despite the tribulations of struggling through the Vermilion River valley, Allen remarks in particular on discovering a natural garden—an open place with a stream and abundant wildflowers:

The following morning—Saturday, September 9—after toiling for five hours through a pathless forest, we emerged, tired, hot and generally uncomfortable, upon a circular opening in the woods, through whose long, waving grass was heard the ripple of a brook. Ferns, waist-high, fringed the edges; streamers of moss waved from the boughs; while many-coloured painter's brush, pink and white spireas, and the graceful columbine grew in profusion around, together with yellow buttercups, pink and white pyrolas, and the ever-present daisy. Blue lupins and larkspur were contrasted with curious yellow and red and white fungi, and the air was sweet with the scent of wild roses. [13]

High in the valley of Surprise Creek, on the morning of September 12, Allen and Carryer awoke to low cloud and falling snow. They continued to ascend the valley despite the snowstorm, but as a result Allen developed a serious physical ailment, fortunately alleviated by his companion:

The exposure had caused in me an enlargement of the palate, preventing clear speaking and causing me much alarm. This was completely cured in ½ hr. by the application of a few drops of sap squeezed from the blisters of the bark of a balsam tree, an Indian remedy suggested by Carryer. [14]

By lunchtime they reached Rock Lake, described by Allen as "surrounded by great black walls,"[15] and by 6 p.m. they could see, at the end of the valley, the ridge that Allen believed was one of Assiniboine's spurs. Snow continued to fall while they waited for a glimpse of the "long-desired, though as yet invisible, mountain."[16] Finally, on the evening of September 15, the moon shone for about an hour, revealing the ridge ahead with walls of 1000–2000 feet on either side—obviously a pass into the next valley, not Mount Assiniboine. Allen describes the view the next morning from what we today call Ferro Pass:

When I finally had an opportunity to observe the other side of the valley, the first object I saw was a beautiful lake lying a little below tree-line at the base of a great glacier-covered wall. Above this lake, encircled by glaciers at the foot of the walls, which rose 3,000 ft. above it, was a smaller lake. The top of the wall was hidden by moving clouds, and I believed it to be Mount Assiniboine at last. [17]

In the afternoon they crossed the pass and descended through burnt timber to the snow-free valley that contained Wedgwood Lake. Just about to leave, Allen took one last look at the wall, and, for an instant when the clouds parted, he saw Assiniboine for the first time:

> ... happening to glance up at the rapidly moving clouds that hid the top of the wall, I observed through a sudden opening a single needle-like point glittering against the blue sky behind like a bit of black obsidian beneath a silver veil. It was indeed Mount Assiniboine....[18]

With this glimpse of the great mountain, they retraced their steps to the Simpson River and then followed it toward Simpson Pass, eventually descending by way of Healy Creek to the Bow River.

WILCOX

Wilcox, now Allen's rival, was successful in securing a place in the 1895 expedition to Assiniboine. The party was outfitted by Wilson, with Ralph Edwards as guide and Bill Peyto as packer. Along with Wilcox, the tourists, or dudes, were, again, Robert Barrett and a friend of his, James Porter. In his "Mountain Journal,"[19] Peyto comments that Wilcox's fashionable appearance raises doubt about his client's stamina for the tribulations of a wilderness trek.

The journey is described in detail by Wilcox in *The Rockies of Canada*, in all its beauty and hardships. After leaving in the rain on July 6, they ascended Healy Creek, reaching Simpson Pass early on July 8, where they found snowdrifts 15–20 feet deep. The south-facing slopes were bare, however, revealing an abundance of white anemones and yellow alpine lilies. The party followed Wilson's route of 1893, through the forest of the Simpson Valley and then leaving the Simpson River to climb to a high valley with steep sides and rock slides: "a landscape like Sierra Nevadas."[20] On July 10 they were able to camp beside a lake that produced a dozen trout, probably Rock Lake, out of which flows Surprise Creek.[21] The climb to the pass at the end of the valley, later called Ferro Pass, was difficult because of snow five to six feet deep. Once over the pass, they descended to a valley of burnt timber, with Wedgwood Lake and, beyond, the peak of Assiniboine rising through the smoke of forest fires. Wilcox has happy recollections of camping beside Wedgwood Lake in the midst of burnt trees and fireweed, the smoke glowing in the sunlight, as he listened to the song of the white-crested sparrow.

On July 12, after climbing past Cerulean and Sunburst Lakes, they reached their goal: Mount Assiniboine reflected in Lake Magog. The men made camp on a "treeless moor,"[22] with Lake Magog to the left, giving them a spectacular view of Assiniboine straight ahead. Bill Peyto returned to

Banff to replace a horse, and while waiting for his return, the others climbed lesser peaks to get a better view of the formidable giant. They did not attempt to climb Assiniboine.

When Peyto reappeared, he accompanied Barrett and Wilcox on a very strenuous circuit of the mountain—an excursion few tourists have undertaken since. Erling Strom and his friend Victor Kutschera would make a similar circuit in the opposite direction 30 years later.[23] Peyto, Barrett, and Wilcox packed three days worth of food and just the bare necessities: one blanket each, an axe, cups, knives, and a camera. Heading northeast on July 26, they climbed through the alpine meadows to Wonder Pass at 8000 feet and then descended a deep valley to Terrapin Lake, the middle lake of three, where it was very hot with many mosquitoes. The climb out of the valley took them to a yet higher valley with meadows and lakes leading to Marvel Pass on the Great Divide, where Wilcox observed the water flowing in the opposite direction. After a day of spectacular views and alpine meadows, they now descended into a burnt forest with so much fallen timber that they spent three hours walking not on the ground but above it, sometimes 10 or 12 feet.

Camp the first night was on a rocky ledge near a stream which they believed flowed from a location near Mount Assiniboine, probably what is now known as Assiniboine Creek coming from the small lakes Assiniboine and Lunette. Wilcox ruefully remarks that they had much firewood "which was well seasoned, required but little chopping, and was already half converted into charcoal."[24] The three hours spent scrambling over charred logs had made them "black as coal-heavers."[25] The next day, July 27, after following the stream up the valley, they realized they were in a cul-de-sac and attempted to climb over a ridge to the south. A 500-foot wall appeared to be impassable, and as they were contemplating defeat, the clouds suddenly lifted, revealing "the south side of Mt. Assiniboine, a sight that probably no other white men have ever seen."[26]

With renewed vigour, the explorers returned to the problem of ascending the ridge, and with Peyto leading, they followed a game trail to the 9000-foot summit.[27] Their descent into the valley to the south brought them to the north fork of the Cross River (now called the Mitchell River), and as they headed west along a trail in the remote wilderness valley, Wilcox suddenly stumbled on his rival, Samuel Allen, who had returned with Dr. Howard Smith[28] to gain more information about a possible ascent of Assiniboine. Both parties shared the same objective, and both had, incidentally, been outfitted by Tom Wilson.[29]

Wilcox, Peyto, and Barrett followed the valley straight for six miles, and then it veered north into another tract of burnt timber, probably in the vicinity of Wedgwood Lake, where they made camp at 10 p.m., overcome with fatigue. By starting at 4 the next morning, July 28, they were able to return to their camp near Assiniboine at 6:30 a.m., accomplishing the 51-mile circuit in less than 48 hours. In his journal Peyto acknowledges the toughness of his clients on an expedition that would tire out a mountain goat.[30] On the journey back to civilization, the guide Ralph Edwards rejoined the group after an absence of two weeks, and they retraced their steps to the Simpson River, which led them to the Vermilion River and, eventually, to the Bow River at Castle Mountain. They arrived in Banff on August 5 after 29 days on the trail.[31]

WILCOX: A SECOND ATTEMPT

Intrigued by his first visit to Assiniboine, Walter Wilcox decided four years later to return in July 1899, again outfitted by Tom Wilson, with Bob Campbell as guide and accompanied by American Henry G. Bryant, the Arctic explorer, and Englishman Louis J. Steele. They tried to hire a Swiss guide but were unsuccessful because of the length of their trip. Instead, they took rope and three ice axes, intending to climb the lower slopes themselves. Wilson suggested a new approach by taking a branch of Healy Creek to the Sunshine Meadows. When the party climbed the steep trail above the larches they found "veritable gardens of wild-flowers"[32] and "to the south a steep mountain of striking outline rose above the meadow expanse. It was Mt. Assiniboine."[33]

The next morning, conditions became dramatically different when rain turned to snow and low cloud obscured the landscape, forcing them to rely on their contour map, compass, and aneroid. Unsure of the right track, they finally located the little lake on the map, probably Howard Douglas Lake, and climbed a desolate pass, Citadel, before descending steeply for 2000 feet to the Simpson Valley, where they camped. The next day, they travelled through a valley of weird limestone shapes, "valley of the gnomes,"[34] or what is now called Valley of the Rocks. Wilcox describes how the valley ends in a small lake surrounded by limestone, now called Og, where "Mt. Assiniboine suddenly appeared as we reached the lake."[35] As well as nearly losing their way, the men experienced other

accidents, including a broken ice axe when a horse fell against a tree and the loss of Wilcox's knapsack containing his scientific instruments.

While Wilcox and Campbell went searching for the lost possessions, Bryant and Steele took advantage of the remaining two ice axes to climb Assiniboine by themselves. At 10,000 feet they realized a storm was brewing, and in their haste to descend, both almost lost their lives when Steele slipped at the top of the last ice slope, dragging Bryant with him. Steele fortunately was able to swing his ice axe into a narrow crevice and arrest his fall while Bryant flew over him, also safely coming to a stop and preventing a rapid and probably fatal descent of some 600 feet. The attempt of Bryant and Steele to climb Assiniboine is the first to be recorded and nearly resulted in the first serious accident, precipitated by threatening weather.

The storm did materialize with rain and wind overnight, and the next day brought more wind and showers of hail and snow, obscuring the mountains and prompting Wilcox's comment that "Mt. Assiniboine seems to be a gathering place for storms."[36] The bad weather drove them back to Banff, but this time by way of the Spray River. While unsuccessful in climbing the mountain, Wilcox's group pioneered new routes to and from Assiniboine which would be followed by later visitors.

Wilcox's photographs, together with his detailed descriptions of the beautiful alpine landscape and the challenge of climbing Assiniboine, continued to intrigue aspiring mountaineers. In 1900 an artist travelled to the mountain, a man from Montreal named Farrell,[37] whose presence would prove largely responsible for the failure of that expedition to reach the summit. The other members of the party included the Walling brothers from Chicago, the cook Jimmy Simpson, and three climbing guides: Edouard Feuz, who had been hired by the CPR in 1899, and two recent arrivals, Henry Zurfluh and Charles Clarke.

Farrell had asked Feuz to look after his watercolour box on the trip to Assiniboine, but Feuz deliberately lost it because he was more concerned with transporting the schnapps.[38] Consequently, Farrell had nothing to do while the others were climbing Assiniboine, and he amused himself by shooting ducks. When the climbers reached a band of rock running from east to west just below the summit, the guides refused to climb any higher. According to Jimmy Simpson, the guides claimed small avalanches were being caused by the vibrations from the gunshots below.[39] Thus did Farrell,

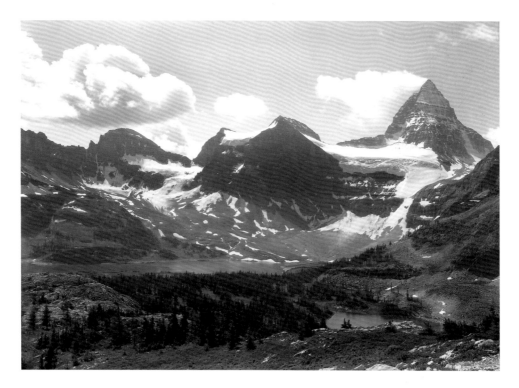

BYRON HARMON, (l to r) Mount Terrapin, Mount Magog, Mount Assiniboine and Magog Lake from the Nublet, n.d. Whyte Museum of the Canadian Rockies (v263/NA 71-667).

who had no mountaineering ambitions, inadvertently prevent what might have been the first ascent of one of the most intriguing mountains in the southern Rockies.

The party's mishaps did not end there, however. On the return journey, Jimmy Simpson was forced to bring the pack train by way of Canmore because of downed timber, while the guides and the Walling brothers continued slowly with one horse up the Spray River toward the Banff Springs Hotel. The Wallings felt so hopelessly lost that they shot their horse for food just 50 yards from a lumber road and near the hotel. The guides, presumably in disgust, abandoned their clients and spent the night in the hotel and, the next day, reported the Walling brothers missing.[40]

Assiniboine Scaled at Last

The Outram expedition: The legacy of Bill Peyto

When Wilcox and Barrett were stopped by a 500-foot wall south of Mount Assiniboine, Bill Peyto found an escape from the cul-de-sac by following a faint animal track, allowing the explorers to complete the first circuit of the mountain's base in 1895. Six years later Peyto would be a key figure in the first ascent of Mount Assiniboine by James Outram. The CPR had hoped that Sir Edward Whymper, the conqueror of the Matterhorn, would bring international recognition to a first ascent of the highest peak in the southern Rockies. Whymper proposed doing some climbs and sending accounts of them to English newspapers and journals in return for free travel, accommodation, and assistance for himself and four Swiss guides.[41] His visits to the Rockies in the years from 1900 to 1905, and again in 1909[42] when he was in his sixties, did create the desired publicity, and although Whymper did not attempt Assiniboine, his difficult personality would prove instrumental in persuading Bill Peyto to guide the man whose attempt on the mountain would finally succeed, in the late summer of 1901.

Upon his return from service in the Boer War, Peyto had seen an opportunity to start his own guiding business in Banff because Tom Wilson was concentrating on taking clients into the mountains from Laggan and Field. With some luck, Peyto received an introduction to Whymper and convinced the famous mountaineer that he could offer a better rate than Wilson. Despite his misgivings about his prospective client, Peyto was eager to start his guiding business, and he signed an agreement with Whymper on June 17, 1901.[43] Peyto noted in his journal that Whymper was bad tempered and considered himself superior, frequently sending the hired help to make observations while he stayed in camp.[44] Peyto did his best to cope with his difficult new client by simply staying out of the man's way. But when the camp was moved to Yoho Lake in very hot weather, he realized that in order to avoid a violent confrontation that would cost him his contract, he would have to use two sick horses as an excuse to escape for a few days to Banff.[45] On his way through Field, Peyto appealed to Tom Wilson, who graciously offered to intervene by sending one of his men to assist and by going to see Whymper himself. On this visit Wilson fortuitously introduced Reverend James Outram to Whymper, who immediately invited the young English climber to join his party.[46]

Peyto quickly realized Outram had ambitions to climb Assiniboine. Furthermore, news arrived from Field that Wilcox's third attempt on the mountain, on July 30, had failed. With Bryant and Edouard Feuz, Wilcox had reached 11,000 feet before turning back. They needed three more hours to gain the summit, but that would have meant spending the night on the mountain and risking frozen feet.[47] Peyto seized the opportunity and offered to guide Outram to Assiniboine, getting him there and back in record time and with little expense.[48] The challenge of tackling this formidable mountain would enable Peyto to extricate himself from his contentious relationship with Whymper.

OUTRAM DESCRIBES HIS OBJECTIVE ...

James Outram wrote two similar accounts of his ascent of Assiniboine: the first in 1902 in *The Alpine Journal* and three years later in his book *In The Heart of the Canadian Rockies*.[49] The account in his book begins by giving three reasons for the notoriety of the mountain: the close resemblance to the Matterhorn, although Outram himself believes Assiniboine to be more like Dent Blanche; the photographs and writing of Walter Wilcox, whom Outram calls Assiniboine's biographer; and, probably most important, no other mountain in the Rockies had had so many failed attempts.

Outram's description of Assiniboine's appearance makes it sound intriguing indeed. As the highest peak in the southern Rockies, at 11,820 feet, its pyramidal shape stands out because the summit is higher than the surrounding mountains. Assiniboine is a massive giant with five spurs covering an area of 30 square miles and with at least 12 lakes at its base. The view of the mountain from Lake Magog and Sunshine Meadows to the north is most spectacular, with the peak rising 5000 feet from the valley and 3000 feet from the glacier at its base. The eastern and southern sides are forbidding with precipices of 5000 to 6000 feet, while the northern triangle has bands of cliff that are perpendicular, making this approach a challenge as well. Outram paints a picture of Assiniboine as a castle with fortifications and artillery driving back invaders, and his secretive expedition is described in militaristic terms.

Blankets and food for the trip were obtained in Field from Miss A.E. Mollison, who was privy to the planned assault on Assiniboine. Peyto, instructed by Outram to keep their plans a secret, went ahead to Banff to talk to Wilcox about Assiniboine and to establish a secluded camp beside the Bow.[50] Outram, with guides Christian Häsler and Christian Bohren, took the train to Banff, where they met Peyto and camped in their hiding place on August 30. By 1:30 p.m. the next day, they were ready to set out; the weather was fine but a haze around the peaks threatened rain. Outram describes the group as having two parts: the advance party consisted of the cavalry, with Peyto leading, followed by four pack horses and Jack Sinclair, the assistant packer; behind came the infantry, with Outram and the two Christians.

They travelled peacefully along the broad Bow valley until they reached Healy Creek, where they left civilization to ascend a steep trail in a narrow gorge. Strong winds and driving rain assailed them before they reached their first camp in Simpson Pass. The next day, the weather was good as they crossed the pass into alpine meadows filled with flowers and dotted with small lakes. Mount Assiniboine beckoned them through the haze some 14 or 15 miles away. They soon dropped 1500 feet into a forsaken, narrow area filled with burnt tree trunks and logs fallen over many wild berries growing underneath. The desolate atmosphere continued in the silence of the next valley, with light rain and a gloomy sky. Eventually the sky lightened and the landscape improved, with Assiniboine again in view only five miles away. The sound of thunder greeted them as they made camp beside trees and a stream near Lake Magog.

Overnight the weather was threatening, with showers, dark clouds on the horizon, and thunder in the distance. The party's anxiety grew as the stillness was broken many times by avalanches of rock and ice from the Assiniboine glacier just a mile away. Sleep was difficult; they arose in the moonlight but waited until sunrise at 6 a.m. before setting out for the glacier at the base of Assiniboine.

Peyto had suggested using Wilcox's approach by way of the southwest side, but Outram wanted to avoid a difficult camp at the mountain's southwestern base. He proposed an ascent from their Lake Magog camp and the crossing of the spurs at high altitude, thus gaining access to the southwest ridge more easily. By 7:30 a.m. four climbers, Peyto, Outram, Häsler and Bohren, were on the glacier, and just 40 minutes later they reached the northwest ridge. Dropping to the glacier, they

were able to move to a pass at the base of the southwest ridge and see for the first time the unknown part of the mountain, a series of ledges making access possible. Their good luck in finding a route, however, was offset by poor visibility, drizzling rain and sleet. Realizing that a successful ascent was unlikely, they decided to try anyway. They unloaded the tent and blankets, had another breakfast at 10:30 a.m., and started out in the low cloud, building cairns to find the way back.

At 10,000 feet Peyto decided he wanted to pursue his passion for prospecting. Outram had asked him to join the summit attempt, and even though Peyto desperately wanted to be included, he realized that his inexperience as a mountain climber might lead to the party's failure.[51] At 10,750 feet, the other three climbers faced a 70 to 80 foot wall with its top disappearing into the cloud. First, they worked their way to the right along the base of the wall, coming to a precipice 6000 feet high! They found nothing but air in front and on both sides. Peering around the angle of rock, they could see an awesome face which appeared perpendicular:

> The wall rose sheer above; a huge abyss, with wreathing clouds, yawned at our feet; peering round the sharp angle we were confronted by a vertical face some thousands of feet in height, and below the narrow ledge of our approach the mountain-side shelved rapidly away to unknown depths. This put an abrupt termination to our investigations in that direction....[52]

Obviously this route was not feasible, and they retraced their steps, this time going to the left along the cliff base where they found a rift allowing them to clamber to the top of the cliff. The climbers gained a summit by following a broken ridge from the west; however, this turned out not to be the peak of Assiniboine but another one of just over 11,000 feet on a southwestern ridge:

> Never having imagined a subsidiary peak, and being closely wrapped in cloud, with driving sleet and hail, we were quite lost. . . . We shouted in this direction and that, and at last received an echoing answer from an evidently higher and larger mass, lying behind the ridge by which we had just reached our little summit.

> It was now evident that a second, minor summit, severed from the main peak by a considerable break, must rise from the south-eastern ridge, which was far longer and less steep than we anticipated.[53]

After an hour waiting for the mist to clear to gain some idea of the peak of Assiniboine, they started down at 1:30 p.m. to meet Peyto at 10,000 feet and then descend to camp, hoping for better weather to try again.

At 6:10 the next morning, September 3, Outram, accompanied by Häsler and Bohren, set out and quickly ascended to the wall of the day before, reaching it at 10:30. Moving to the left, they crossed a snowy couloir with ice underneath, and they were on track for the summit of Assiniboine 1000 feet above. The escarpments had small ledges, pinnacles, and vertical crevices, and to move between the ledges, they had to cut steps in hard snow or ice. The rock was not only rotten but covered with ice because of the rain and sleet of the day before. Moving with extreme care, testing each hold, they reached the south ridge, where they could see the summit 300 feet above which could be reached by a snow ridge. At the top they found a double summit at either end of a narrow ridge 150 feet long. Individually, the climbers looked over the edge at the highest point down 6000 feet to the glacier. The panorama, though hazy, was wonderful:

> Perched high upon our isolated pinnacle, 1,500 ft. higher than any neighbouring peak, range upon range of brown-grey mountains followed one another to the far horizon. Many were glacier-hung and laden with snow, and the vast chasms intervening loomed dark and deep on every side, while many little lakelets gleamed in the sunlight, nestling in the somber valleys. Far to the N.W. lay the familiar summits of the railway belt, from many of which we had looked on former occasions with longing eyes to the proud peak from which we now were gazing back. To the E., the sudden clear-cut line appeared, beyond which the prairies swept away from the base of the huge cliffs that wall their western limits. On the S. and W., new worlds (to us) were opened out, with several prominent and interesting peaks to lure the mountaineer to further penetrating into the wild and desolate interior.[54]

Outram courageously suggested a traverse of Assiniboine with a descent on the northwest ridge between two vertical faces. Three and a half hours of perilous climbing down over icy, rotten rock brought them to ice at the base of the ridge, then to snow and finally to rock, where they unroped and climbed down to the glacier and then to camp:

> Before turning in we took a last look at the great obelisk above us, brilliant in the moonlight beneath the dark canopy of a star-strewn sky; and next morning awoke to a world of snow, which lay thick and soft around, whilst whirling masses of storm clouds drifted across the

mountain and wrapped its summit, giving but an occasional glimpse of its steep flanks, covered with freshly fallen snow.[55]

They spent another two days in driving snow as they retraced their steps to the head of the Simpson valley and descended Healy Creek to the Bow, and while the horses were given a rest, the guides and Outram walked to Banff in two hours. Outram notes in his book that they climbed Assiniboine on the last day before the weather changed, and, in his opinion, this climb was the most significant of any in North America. The total time for the trip was five days and five hours.[56]

Following in Outram's Tracks

DOUGLAS ...

The second ascent of Assiniboine took place in July 1903 when W. Douglas of Edinburgh was guided by Christian Häsler and Christian Kaufmann along the same route Outram had used.[57]

... THEN BENHAM

On August 1, 1904, Peyto was again the outfitter, with packers Jimmy Wood and Jesse Trot, when he set out for Assiniboine with an English mountaineer, Gertrude Benham, and her guides Hans and Christian Kaufmann. Benham, single and 37 years old, had already had a remarkable career in the Swiss Alps, with 130 ascents, before coming to the Rockies in June 1904. On July 20, with Christian Kaufmann as guide, she had persevered and climbed the Hourglass couloir from Moraine Lake and made the first summit of Mount Fay, while the man after whom the peak was named, Charles Fay, was attempting the same mountain from Consolation Lake but got turned back by snow and falling rock.[58] After her coup at Moraine Lake, Benham became the first woman to climb Assiniboine. Her account in the *Canadian Alpine Journal*[59] tells of being woken at 3 a.m. by Christian Kaufmann and having to dress in the pitch-black tent because they had forgotten to bring candles. At 4 a.m. Benham and her two guides set out and began their ascent by cutting steps in the snow slope leading to the glacier. Once on the glacier, they followed the base of the peak around to cross the west ridge

and traverse a snow slope, reaching the side of Assiniboine opposite their campsite beside Lake Magog. As they ascended the mountain over steep slabs covered with loose, rotten rock and ice, they found the corpse of a small mammal, presumably dropped there at such an altitude by a very large bird. They reached Assiniboine's summit at 2 p.m. only to find that smoke obscured the view of distant peaks. Benham, in her understated manner, mentions that the descent in the afternoon was by a different route because the softer snow was unsafe. The three victorious climbers returned to camp at dusk, after almost 17 hours.

... AND BEACH-NICHOL

Another remarkable woman also came to Assiniboine in the summer of 1904: Mrs. Mary de la Beach-Nichol, the wealthy daughter of a former Chancellor of the Exchequer of Great Britain. Now that her six children were grown, she was free to work as a lepidopterist, and she hired Jimmy Simpson to guide her for the summer so that she might collect rare and unusual butterflies and moths for the British Museum. After visiting the Yoho valley and Lake O'Hara, they went to the Assiniboine area.[60] Simpson, the mountain man, now found himself chasing butterflies or holding the collection box as he followed this diminutive, grey-haired woman in a black dress and old panama hat, holding an ear trumpet in one hand and a butterfly net in the other.[61]

VAUX WALCOTT

Mrs. Beach-Nichol was not the only female explorer with a scientific interest in the Assiniboine area. She was followed a few years later, in 1907, by George and Mary Vaux, brother and sister of the family renowned for the photographic study of the Illecillewaet Glacier. Mary is particularly famous for her impressive collection of scientifically accurate, life-size watercolours of wildflowers, many discovered on her extensive travels with her husband, Dr. George Walcott, during his geological studies in the Canadian Rockies.

In 1925 Mary Vaux published reproductions of her paintings in her impressive five-volume *North American Wildflowers*. Each image is accompanied by a brief description indicating where

MARY VAUX WALCOTT, *Bearberry* (*Arctostaphylos uva-ursi*), 1916. Watercolour on paper, 25.4 x 17.8 cm sheet. Smithsonian American Art Museum, gift of the artist (1970.355.449).

Moss Gentian (*Gentiana prostrata*), 1916. Watercolour on paper, 25.4 x 17.8 cm sheet. Smithsonian American Art Museum, gift of the artist (1970.355.516).

the specimen was found, and the collection includes flowers from the Assiniboine area such as bearberry, moss gentian, alpine pointvetch, elkslip, and white globeflower. The Assiniboine water-colours are dated 1916, except for the white globeflower, which bears the early date of 1899. In her description of the globeflower, Mary states that she found it near Mount Assiniboine in meadows at 6500 feet, probably on the same trip in 1916 when she discovered the four other flowers. A note in the lower left corner of the globeflower painting, however, gives the location as near the Asulkan Shack (Glacier National Park) in August 1899. This curious discrepancy suggests that she saw it in both places and used the 1899 image to illustrate her book of wildflowers.

Mary Vaux must take the honour of being the first artist to visit the Assiniboine area. The "Forward" to Volume One offers a fascinating glimpse into her motivation and the problems of

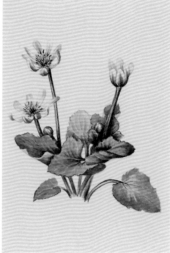

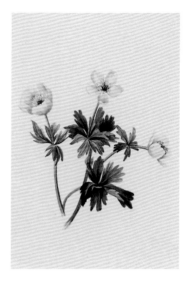

Mary Vaux Walcott, *Alpine Pointvetch* (*Oxytropis podocarpa*), 1916. Watercolour on paper, 25.4 x 17.7 cm sheet. Smithsonian American Art Museum, gift of the artist (1970.355.619).

Elkslip (*Caltha leptosepala*), 1916. Watercolour on paper, 25.4 x 17.8 cm sheet. Smithsonian American Art Museum, gift of the artist (1970.355.624).

White Globeflower (*Trollius albiflorus*), 1899. Watercolour on paper, 25.4 x 17.6 cm sheet. Smithsonian American Art Museum, gift of the artist (1970.355.690).

sketching in the field. Mary explains that as a child she had instruction in sketching wildflowers, but she was not inspired to concentrate on this beautiful but small part of the natural world until years later at Glacier House when a botanist friend asked her to paint a rare alpine flower. Her annual three to four month field trips in the Rockies with her husband, on which she estimates they covered 5000 miles of mountain trails, allowed her to locate and sketch many different specimens. Her aim, in addition to accuracy, was artistry: "to depict the natural grace and beauty of the plant."[62] Her search for wildflowers in high passes or on mountainsides often necessitated building a fire to warm her fingers sufficiently to sketch. Back in camp, another difficulty arose in trying to adjust the light and shade in a white tent which diffused the light. Mary would often sketch during the time it took to organize the pack train for departure. While she adapted well to life on the trail, her main

problem was finding good specimens of fragile alpine flowers. The brief growing season in the mountains limited the number of sketches she could do on one trip, and the weather, at times too cold, too dry, or too wet, could easily spoil the blooms. For these reasons, she saw perfect examples of some wildflowers only two or three times in all her travels on horseback. After the publication of her monumental work on wildflowers, Mary continued to attend ACC camps and join the Trail Riders on their expeditions, where she became affectionately known as "The Artist."[63]

WILCOX: HIS PERSEVERANCE FINALLY REWARDED

The first photographer of Mount Assiniboine, Walter Wilcox, was again accompanied to the mountain by Bill Peyto in 1905. This time, Wilcox was rewarded for his years of perseverance, and he finally reached the summit. His writing and photographs did much to celebrate the beauty and the challenge of Mount Assiniboine. Even today, by reading his *Camping in the Canadian Rockies* (enlarged and revised in *The Rockies of Canada*), one is inspired by his appreciation of this awesome alpine setting. Wilcox presented Peyto with a copy of his book, and Peyto describes in his journal how he stayed up very late one night reading it from cover to cover.[64] He was appreciative of Wilcox's comments about his horsemanship and bemused by his image as a cowboy:

> Peyto assumes a wild and picturesque though somewhat tattered attire. A sombrero, with a rakish tilt to one side, a blue shirt set off by a white kerchief (which may have served civilisation for a napkin), and a buckskin coat with a fringed border, add to his cowboy appearance. A heavy belt containing a row of cartridges, hunting-knife and six-shooter, as well as the restless activity of his wicked blue eyes, give him an air of bravado. He usually wears two pairs of trousers, one over the other, the outer pair about six months older. This was shown by their dilapidated and faded state, hanging, after a week of rough work in burnt timber, in a tattered fringe knee-high. Every once in a while Peyto would give one or two nervous yanks at the fringe and tear off the longer pieces, so that his outer trousers disappeared day by day from below upwards. Part of this was affectation, to impress the tenderfoot, or the "dude," as he calls everyone who wears a collar. But in spite of this Peyto is one of the most conscientious and experienced men with horses that I have ever known.[65]

31

Another famous mountaineer, second in reputation only to Whymper, was the Englishman Dr. Thomas G. Longstaff, invited as the distinguished guest at the 1910 ACC camp. Longstaff particularly wanted to climb Assiniboine at the end of June before the camp, and, together with his sister Katharine Longstaff, he was accompanied by the Swiss guide Rudolph Aemmer and outfitter Jimmy Simpson, assisted by the singing packer and guide Ernie "Caruso" Brearley.[66] Arriving at the base of Assiniboine, they encountered Felix Wedgwood, a descendant of the famous English pottery family, who had just failed in his attempt to climb the mountain, even with two Swiss guides. Climbing conditions remained poor and Katharine was forced to stay behind while her brother and Aemmer ascended the northwest face in icy conditions, traversed the mountain to descend, and hiked back to camp after a gruelling 21 hours.[67] Katharine was able to climb a peak just north of Assiniboine shortly after, and in her honour her companions suggested naming the mountain after her. The name Katharine, however, had already been given to a lake near Dolomite Pass, and the Canadian Geographic Board asked Katharine Longstaff for another suggestion. She happily chose the name of the man she had met at the base of Assiniboine: Wedgwood. They had attended the ACC camp together and soon were married.[68]

WEDGWOOD

Felix Wedgwood had another chance at Assiniboine later that summer, with Joseph Hickson, a professor of philosophy from McGill, and Hickson's favourite guide, Edward Feuz Jr., who eventually would spend 25 seasons with Hickson.[69] Edward's cousin Gottfried completed the climbing party. Now the weather was warm, hazy, and without wind. They reached the summit, but a storm overtook them on the descent. Just as they left the lower band of rocks and were preparing to cross the slope that approached the glacier, lightning struck, and all four were thrown to the ground. Fortunately, no one was hurt, but they endured a terrible storm of hail, rain, and later snow before struggling back to camp.[70]

Popularizing the Mountain: A.O. Wheeler

The early climbs of Assiniboine were spectacular. Not only did the mountaineers overcome this formidable giant, but they also became explorers in their quest to reach the base of the mountain. Assiniboine is still a beacon for climbers, as the summit is visible from afar, higher than all the surrounding peaks. But the mountain also towers over a beautiful alpine landscape which from the early days has attracted hikers, trail riders, skiers, and artists. A.O. Wheeler, one of the founders of the Alpine Club of Canada in 1906, along with R.M. Cautley,[71] after whom the mountain on the Continental Divide is named, came to the area to survey the Alberta-British Columbia boundary in 1913 and 1917. Wheeler astutely realized the potential for tourism and secured freehold title to 44 acres near Lake Magog in 1920.[72] He subsequently sold the land to the ACC in April 1924, and the club, in turn, leased the site back to him the following July for two dollars a year.[73]

This Assiniboine property became the destination for Wheeler's ambitious walking and riding tours, which left Banff twice a week during July, August, and September, beginning in 1920. The tour was advertised as a three to five day circuit of about 75 miles starting at Banff's Middle Springs and heading down the Spray River to the Spray Lakes, then up Bryant Creek to Assiniboine. The return journey was north along the Continental Divide past Gog Lake and the Valley of the Rocks, over Citadel Pass to the Sunshine Meadows and down Healy Creek to the Bow River, where the hikers were picked up by boat at Mount Edith landing.[74] Wheeler named many of the geographical features, including the lakes, along the way.[75] Such an ambitious tour, especially for people on foot, necessitated additional support and comfort. Wheeler went into partnership with Ralph Rink, who would provide horse transport for guests or their baggage. Together they formed Ralph Rink & Co., and Wheeler agreed to make Rink the official outfitter for the ACC as well.[76]

In addition to horses to carry their luggage, the intrepid walkers also needed accommodation in designated places along the way. To this end, Wheeler convinced J.B. Harkin, the Commissioner of Dominion Parks, that permanent camps were necessary at Middle Springs and Assiniboine, with additional camps at the former Eau Claire lumber camp on the Spray; Goat Pass, near the lower Spray Lake; Trail Centre near Spray Falls, above upper Spray Lake; and Sunshine in the meadows near the head of Sunshine Creek, with each camp somewhere between 7 miles and 16 miles from the next.[77] By the beginning of their third season, in 1923, Wheeler promised in his promotion in the CPR pamphlet

Resorts in the Canadian Pacific Rockies[78] that guests could enjoy Wonder Lodge at Assiniboine, a building with a living and dining room and adjoining tents for sleeping. Construction of Wonder Lodge and several smaller cabins on the ACC property at the north end of Lake Magog eventually took place in the summer of 1925.[79] Today these cabins are known as the Naiset Huts, operated by BC Parks.

Wheeler's tours were popular in 1920 and 1921, but by 1922 complaints arose because Wheeler was suggesting the tours were sponsored by the ACC. Further, Ralph Rink was thought to have an unfair advantage in the outfitting business because he could use the camps on the tour to launch longer trips, an arrangement not permitted in the government agreement.[80] Business started to decline: there were only 29 customers in all of 1924. The tours ceased in 1926, and Wheeler gave up the leases of Middle Springs and Assiniboine to Pat Brewster in 1930.[81] Although Wheeler's tours did not survive for long, they apparently did have a beneficial side effect: his promotion of the recreational possibilities of the area and his knowledge as a surveyor were undoubtedly instrumental in the B.C. government's having set aside 12,850 acres in 1922 as Assiniboine Provincial Park.[82]

Arthur P. Coleman: Artist and Explorer

The earliest dated images of the landscape in the Mount Assiniboine area are by a professor of geology from the University of Toronto who visited the area in 1920: Arthur P. Coleman, who had succeeded A.O. Wheeler as ACC president from 1910–1914. Born in Lachute, Quebec in 1852, Coleman spent most of his life in Canada apart from two years of study in Germany to gain his Ph.D. In addition to his academic career, Coleman painted in watercolours, having started at a young age. He had exhibited his work with the Ontario Society of Artists (1880–1904), the Royal Canadian Academy (1881–1888) and the Toronto Industrial Exhibition, now called the Canadian National Exhibition, (1881–1901).[83] The collection of Coleman watercolours in the Royal Ontario Museum is substantial: 164 images done on field trips[84] from Newfoundland to the B.C. coast. Coleman was obviously attracted to the mountains, because the ROM collection includes 55 watercolours of the Rockies and the Selkirks and 21 of the Mount Robson area.

Coleman was intrigued by the report of David Douglas, a botanist, who had climbed a mountain in the vicinity of Athabasca Pass in May 1827 and claimed that this mountain, which he named

Mount Brown, and another in the area, Mount Hooker, also named by Douglas, were 16,000 or 17,000 feet high.[85] Coleman first set out to find these mysterious giants in 1885 by taking the train to a point near Golden. He returned in 1888 hoping to find a way to Athabasca Pass, but he found this route impossible. In 1892 he resumed his quest, this time from the foothills west of Calgary, but after 800 kilometres he still was unable to reach Athabasca Pass.

On his fourth attempt, in the summer of 1893, Coleman reached the fabled mountains, only to discover that they were not nearly as high as reported.[86] Douglas' mistake appears to have arisen because he accepted at face value an estimate for Athabasca Pass as being 11,000 feet, or 5000 feet higher than the pass actually is, a figure that seems to have come from David Thompson.[87] Using 11,000 feet as his base figure, Douglas naturally assumed that his mountains were 5000 or 6000 feet higher, bringing them to the towering height of 16,000 or 17,000 feet. Coleman's discovery was not easily accepted, because the mountaineering community still wanted to believe these high mountains existed.

Walter Wilcox and three companions set out in 1896 to travel north from the headwaters of the Bow River, making a trail for horses that would later be the basis for the Banff-Jasper highway in the 1930s. Wilcox did not find the mysterious mountains either.

J. Norman Collie, a mountaineer and chemistry professor, was convinced his fellow scientist Douglas could not have made such an obvious error, so he travelled to Athabasca Pass in 1898 to disprove Coleman's assertion. Although he made a first ascent of Mount Athabasca and was the first to see the Columbia Icefield, he finally had to admit that Douglas had made a mistake.[88]

Publicizing the Mountain: The Trail Riders, the Artists and the CPR

Although Wheeler's walking tours had died out, the idea of taking tourists into the mountain wilderness remained very much alive. In 1923 the Trail Riders of the Canadian Rockies came into existence as a result of a mountain snowstorm. R.W. Sandford, in his history of the organization in honour of its 75th anniversary in 1998, recounts how a group of trail riders, including John Murray Gibbon, chief publicist for the CPR, and several influential friends, among them H.B. Clow, president of Rand McNally Map Makers, R.H. Palenske, an artist from Chicago, and Byron

Harmon, official photographer of the Alpine Club of Canada,[89] were snowbound for three days in the Wolverine Pass, near the Tumbling Glacier. Having ample time for discussion while waiting out the storm, the group formulated the idea of an organization to promote horse travel in the Canadian Rockies.

Gibbon realized the advantages of such a club in advertising the CPR,[90] and he was able to interest some important people to serve on the first governing council, including outfitter Tom Wilson, guide Jimmy Simpson and artists Belmore Browne, Mary Vaux Walcott, and Carl Rungius. Through the Trail Riders club the artists had easier access to remote parts of the Rockies; they could travel in relative comfort and enjoy the company of the other riders. Gibbon would later encourage A.C. Leighton to join the Trail Riders so that he could reach the high mountain passes with the wilderness scenery he preferred to paint.[91] Leighton did not need much urging, according to an anecdote in the club's *Bulletin*:[92] in the summer of 1927, having arrived from England too late to join the trail ride to Assiniboine, he rode 36 miles in one day to catch up with the group at Lake Magog, despite never having been on horseback before. Leighton was so impressed with the alpine scenery that he returned to sketch at Assiniboine a short time later.

With the patronage of the CPR, Gibbon started publicizing the new organization in regular bulletins as early as 1924. These publications included reproductions of paintings by artists such as Browne, Rungius, and Palenske. The artists took a prominent role in running the Trail Riders club, too: Rungius became president in 1929;[93] and the year Palenske served as president, 1937, the main trail ride that summer approached Assiniboine by way of Brewster Creek and Allenby Pass.[94] The cover of *Bulletin No. 47* shows an image by Palenske of trail riders at Lake Magog with Mount Assiniboine above.[95] The trip to Assiniboine had always been popular, from the very first year of the rides, in 1925, and continuing many years later, in 1927, 1932, 1937, 1941, 1950, 1954, and 1977.[96] As early as 1927, the Trail Riders sought permission from the government to build cabins in appropriate locations so that the participants could do a circuit similar to Wheeler's walking tours.[97]

Skiing at Assiniboine

ALBIZZI AND STROM

Marquis Nicholas degli Albizzi, the winter sports director at Lake Placid, New York, subleased the ACC land at Assiniboine from Wheeler on March 31, 1927, so that his party could stay at the cabins that summer.[98] His main interest, however, was in the new sport of skiing, and Albizzi returned to Banff in March 1928, this time with Erling Strom, a ski instructor from Lake Placid. In his book *Pioneers on Skis*, Strom gives credit to Albizzi for having introduced him to Assiniboine, a place Strom would come back to every season for much of his life.[99] Albizzi, on the other hand, only spent time there for a few years and never returned after the summer of 1929, becoming disillusioned after a guest needed an emergency operation for appendicitis.[100]

Strom's account of his first journey to Assiniboine has an amusing beginning.[101] When Albizzi and Strom arrived in Banff by train with four guests—two men and two women—they unloaded their skis and equipment under the skeptical gaze of the locals. Banff did not have a single flake of snow on the ground. Later, Strom ran into an old-timer who insisted the expedition to Assiniboine was madness because of the avalanche danger in Allenby Pass. Strom stoutly defended the efficacy of skiing in the backcountry, maintaining that skis make the country more accessible by opening it up. He subsequently learned he had been talking to the first guide to take a tourist to Assiniboine, Tom Wilson.

Albizzi had commanded storm troops on skis in the Italian Alps during the First World War, and he certainly was not perturbed by any avalanche hazard. The lack of snow, however, was of great concern. Having hired Ike Mills and his dog team to transport food, the party left Banff, dogs and all, in trucks. Fortunately, three miles from Banff they found snow on a trail through the woods, sufficient for the dogs, and when the trail left the Bow valley and the party began to climb, they found still more snow on the ground, enough to ski. The group spent the night in a CPR cabin. The next day, however, Ike refused to take his dog team over the steep mountain passes, so he returned to Banff while the rest pressed on, Albizzi and Strom now carrying 60-pound packs.

They crossed Allenby Pass in perfect weather, descended happily on skis to Bryant Creek and climbed Assiniboine Pass to see Mount Assiniboine for the first time, situated in a valley perfect

for skiing. Seventeen days of sunshine followed, with the most wonderful skiing either Albizzi or Strom had ever experienced; they had the entire valley to themselves, with runs of 2000 vertical feet. Strom decided he wanted to spend most of his life at Assiniboine; he would eventually enjoy 50 summers running the lodge before handing over the management to his daughter Siri. The peak just to the right of Assiniboine as one gazes from the lodge verandah is named after him.

THE EARLY SKI LODGE

Albizzi was so enthusiastic about skiing at Assiniboine that on his return he went to the CPR with a proposal: he would bring guests to Assiniboine both summer and winter by using his connections with the resort at Lake Placid, but he would need appropriate accommodation for his clients. Albizzi persuaded the CPR that Assiniboine provided the best skiing in all of North America. The railway was eager to offer wilderness adventures for its passengers with comfortable accommodation in bungalow camps. Lodges with adjoining cabins had already been constructed at Emerald Lake (1903, enlarged in 1926) and Lake O'Hara (1925–26).[102] The CPR had been able to lease 50 acres on Lake Magog in February 1927,[103] and now, in the summer of 1928, ten workmen constructed Assiniboine Lodge, six cabins, and a sauna.[104] Unlike the Naiset Huts, the lodge was situated out in the open to face the prevailing wind so that the snow would be blown away. Albizzi always fancifully claimed that Assiniboine's wicked witch swept the snow.[105] In the first summer season, 1929, Albizzi operated the lodge while Strom visited Norway. The unfortunate medical emergency, however, convinced Albizzi that he did not want to spend his summers in the wilderness, so the CPR rented Assiniboine Lodge and the cabins to Mrs. Bill Brewster in the summers from 1930–35, while Strom looked after the winter season, between two and four weeks in March and April. Strom was able to buy the lodge, the cabins, and all furnishings from the CPR in April 1936, and he subleased the land for 21 years, commencing in November 1936.[106]

BYRON HARMON, Mount Assiniboine and one of Strom's cabins in winter, 1934. Whyte Museum of the Canadian Rockies (V263/NA 71-679).

Hiking and Climbing at Assiniboine

THE ACC SUMMER CAMPS

The Assiniboine area was very appealing as a destination for hikers, trail riders, and climbers, especially since cabins had been constructed, first by Wheeler in 1925 and then by the CPR in 1928. The Alpine Club of Canada held annual summer camps for its members, and as Wheeler had been President from 1906 to 1910 and was managing director until 1926,[107] it is not surprising that the 15th annual ACC camp was held at Assiniboine from July 27 to August 8, 1920.[108] The camp, dedicated to the honour of members who were veterans of the Great War, had an international clientele, with participants from English, Swiss and American alpine clubs as well as the Canadian one. The Assiniboine location was possible because of the camps set up for Wheeler's walking tours, which

39

provided places to stay on the way in and out. With Ernst Feuz as the principal guide, assisted for part of the time by Rudolph Aemmer, 35 members of the camp climbed Assiniboine: "not a difficult mountain for an experienced climber but not to be attacked by the novice."[109] The beginners gained experience on Mount Magog, just over 10,000 feet.

The 30th annual camp was also at Assiniboine, July 13 to August 4, 1935,[110] with the tents set up on the west side of Lake Magog in the trees and near the stream from Sunburst Lake—the site of the present campground. Ralph Rink, Wheeler's former business partner, was the outfitter, and the CPR loaned Rudolph Aemmer and Ernst Feuz as guides. The focus was on climbing the peaks accessible from the main camp, including Assiniboine. Smaller camps were also established on Mitchell and Aurora Creeks so that The Marshall, Aye, Brusiloff, and Eon could be climbed. Other activities were also arranged: fishing in Marvel Lake, botanical excursions, and sketching trips. The ACC mandate included the encouragement of alpine art, and to this end, speakers around the campfires included two artists, F.H. Brigden and Belmore Browne.

THE HINMAN GIRLS AND LILLIAN GEST

Caroline Hinman, who made a career of leading her "Off the Beaten Track" tours, was introduced to climbing at the age of 29 by the Swiss guides at the Mount Robson ACC camp in 1913. Her first ascent of Mount Pamm (2829 metres) made such an impression that she resolved to return to the Rockies and bring others who might not otherwise be able to experience the alpine environment.[111] She found her clients among well-educated teenage girls from wealthy families, and she regularly led tours to the Rockies each summer for over 40 years, with the exception of three seasons during the Second World War.[112] Hinman's first tour entirely in the Canadian Rockies took place in 1917. She travelled on horseback with her girls from Banff to Mount Assiniboine and then to the Pipestone Valley, eventually reaching Lake Louise. Jimmy Simpson was the outfitter, with Ulysses LaCasse as head guide. The cook, Jim Boyce, made such a positive impression on Hinman that when he started his own business in 1921, she employed him continuously in July and August for 16 years.[113] In fact, Boyce signed Hinman and her good friend Lillian Gest as charter members of the Trail Riders in 1924.

Gest was one of 12 in the group Hinman took to Assiniboine in 1926. After meeting Boyce and his outfit at Seebe, they followed the Kananaskis River southwest before heading west to Marvel Lake[114] and over Wonder Pass to camp at Lake Magog, near the trail to Sunburst Lake.[115] While at Assiniboine, they decided to climb Mount Magog (3095 metres) in two groups, using lariats and branches for alpenstocks. Hinman's tours did not focus primarily on climbing, and the ascent of Magog was an amateur enterprise. The descent became perilous, as it was necessary for Boyce to cut steps in the ice with a Boy Scout hatchet. After getting everyone down safely, he resolved never to climb like that again.[116]

Gest joined Hinman's pack train to Assiniboine in 1931, when they camped beside a small lake above Sunburst,[117] and again the next summer. Starting in 1932, Gest became serious about mountaineering, and eventually had many ascents to her credit. Her favourite guide, Chris Häsler, whom she hired every summer,[118] climbed Mount Assiniboine with her in 1934, but smoke prevented them from seeing Lake Magog below. She did find at the summit, however, a note with greetings from another intrepid mountaineer, Georgia Engelhard, who had made the ascent a few days earlier.[119] Gest and Hinman were together at Assiniboine again in 1935 when they attended the ACC camp at Lake Magog. From the fly camp beside the Mitchell River, Gest was among the group who made the first ascent of The Marshall.[120]

Painting at Assiniboine

FRANK PANABAKER

After Mary Vaux Walcott and Arthur P. Coleman, one of the early known artists of the Assiniboine area is the Canadian Frank Panabaker, who painted The Towers around 1930. In his charming book *Reflected Lights*,[121] Panabaker describes two trips to the Rockies with his wife, Katherine. The first expedition, according to his account "Greenhorns in the Rockies," can be dated to the fall of 1929. When they arrived from Ontario, the couple rented a one-room shack in Banff. After buying two horses and camping equipment, they set out on an adventurous camping trip that took them to Lake Louise, Moraine Lake, the Larch Valley, and eventually to the Bow Lakes, where they saw Mount

Assiniboine 50 miles away. On their return to Banff, Panabaker worked on large canvases in their small shack, trying to cope with poor light and cramped quarters. A painting of Moraine Lake caused so much frustration that he appealed for help to Belmore Browne, an American artist with a summer studio in Banff.

Intrigued by the earlier sight of Assiniboine, Panabaker and his wife returned to Banff on September 15, presumably 1930 or later, where they were met at the station by Pat Brewster and driven the next day to join a pack train for Assiniboine that was assembling at Healy Creek. Brewster had taken over the lease of Assiniboine from A.O. Wheeler in 1930, and the tourists on this trip followed the same route and stayed in the same cabins that had been part of Wheeler's walking tours. Snow started to fall as the pack train climbed toward Sunshine; by nightfall the snow was a foot deep outside the cabin known as Sunshine Camp. Bad weather continued for a week, with more snow and low cloud. When the group arrived at Lake Magog, Panabaker could not even see Mount Assiniboine.

Despite the weather and the departure the next day of three of the tourists, the enthusiasm of the young couple was undiminished. On a sketching trip to Marvel Lake, Panabaker continued to work in a snowstorm until he no longer had the energy to blow the snowflakes off his canvas. By the time he and Katherine decided to return to camp, the trail had been obliterated in the blizzard, and they simply let the horses find the way. In his painting of The Towers, possibly sketched during this trip to Assiniboine, Panabaker portrays a snowy landscape with some sunshine breaking through the storm clouds. Finally, on the seventh day at Assiniboine as he sat working above Lake Magog, he witnessed the glorious unveiling of the great mountain: with the valley still in shadow, the clouds lifted to reveal the peak, turned an orange-red by the setting sun. Panabaker remarks in his book that this sight alone was worth a journey of 2000 miles.

A.C. LEIGHTON

The CPR, in its continuing efforts to promote tourism, encouraged mountaineering by providing Swiss guides, built bungalow camps some distance from the railway for the wilderness adventurers, became the patron of the Trail Riders through John Murray Gibbon, and increased the heritage

of Canadian landscape painting by giving artists free travel on the railway.

A.C. Leighton was first noticed by the CPR when as a young commercial artist he produced a model of Liverpool with moving ships for the British Empire Exhibition. He was offered a job and spent five years, 1924–28, as the railway's chief commercial artist, doing brochure illustrations, creating souvenir books, and painting Canadian scenes as he travelled across the country.[122] Leighton was encouraged to do his own painting as well as the commercial work, though the railway reserved the right to have first choice of his paintings for sale.[123] He saw the Rockies on his first trip along the CPR mainline, in 1924.[124] The wilderness landscape inspired him, and he would have the train drop him off in places where he wanted to paint from nature.[125]

An account of Leighton's 1927 sketching trip survives in his own, pencilled, hand in the

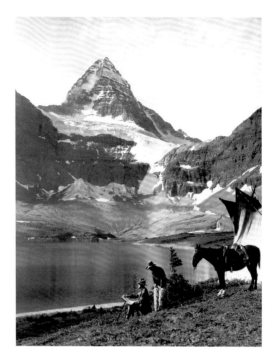

A.C. LEIGHTON painting beside Lake Magog, Mount Assiniboine Park, B.C., n.d. Whyte Museum of the Canadian Rockies (V727/NA 66-2216).

Leighton Art Centre and in the Archives of the Whyte Museum of the Canadian Rockies.[126] He appears to have had at least one other companion, unnamed, and they first travelled by motorboat to Healy Creek Landing on the Bow River, where the horses were kept. After the supplies were secured on the pack animals, they set out for an exciting ride. First of all, Leighton was thrown from his horse; fortunately, he found a soft landing and suffered only a stiff neck. The faint trail was barely a foot wide, with a drop of 200 to 300 feet on one side. Crossing Brewster Pass (now Allenby Pass) the next day was not too difficult, but when they descended into the valley, the horses strayed into the midst of swamps and mud holes. Leighton ruefully remarks that chasing the horses out of this difficult terrain was hard on his pastels and other painting supplies. The ascent of Assiniboine

Pass proved to be very steep, almost perpendicular, and the trail was on a cliff edge. But the first view of Mount Assiniboine was ample compensation for their hardships. Leighton immediately started sketching, forgetting he had not eaten anything since early morning. Snow began to fall and the bitter cold made it impossible to sit still for long. The snowflakes were so dry that Leighton merely blew them off and continued working. He stuffed paper between two pairs of socks to keep warm. When they decided to return over the mountain passes, the snowdrifts were deep, and to proceed safely they had to lead the horses. The descent from Brewster Pass was a nightmare: any trace of a trail had disappeared, the horses started to turn back just as they reached the top, and the blowing snow stung their faces and hands like hot cinders as the daylight quickly faded. When they finally made camp in the dark, Leighton's snow-covered clothing had become icy armour and their food was frozen. The final leg of their journey to Banff the next day was easy compared to their perilous crossing of Brewster Pass in the blizzard. Despite the difficult conditions, the trip was a great success, as the landscape had inspired Leighton to do almost a dozen sketches in about a week.

Leighton developed a preference for mountain solitude where he could sketch the peaks and glaciers without any disturbance from other people and the accoutrements of modern civilization.[127] In 1931, when he married Barbara Harvey, also an artist, the two set off on horseback into the mountains for their honeymoon. Leighton painted with his wife after this, and rather than going with the Trail Riders, he arranged for an outfitter to transport their supplies to the desired wilderness destination and then take the horses out for two weeks or more.[128] On one trip, Leighton barely managed to catch hold of a tree as his horse fell over a cliff.[129] He always worked on his watercolours outdoors and would abandon a watercolour that could not be finished on location.[130] He also worked in pastel, with larger, finished works dating from 1925–35 and smaller sketches, possibly in preparation for oils, from the '40s, '50s and '60s.[131] His studio oil paintings came later in his career, and one, *Mount Skoki*, completed in 1935, resulted in his appointment to the Royal Canadian Academy.[132]

CARL RUNGIUS

Another Assiniboine artist is Carl Rungius, a German-born wildlife painter who had a studio in New York City and first came to the Canadian Rockies at the invitation of the guide Jimmy Simpson.

Actually it was Rungius' wife, Louise, who is credited with rescuing Simpson's crumpled letter from the wastebasket and persuading her husband to reconsider the guide's proposal.[133] Simpson arranged for free travel on the CPR[134] and the couple arrived in Banff in August 1910. Rungius was so pleased with the expedition that he returned each year,[135] exchanging paintings for Simpson's guiding over several decades.[136]

Rungius had already established himself as a big game artist. His painting *Wary Game* (1908), purchased by the New York Zoological Society, was reproduced in their bulletin of January 1910.[137] When Jimmy Simpson happened to see Rungius' portrayal of six Dall sheep on a rocky slope,[138] Simpson realized that the artist was a kindred spirit and sent off his invitation. Rungius' trophy from this first visit was a billy goat,[139] and the following year he painted *The Old Billy* and presented it to Simpson, who hung it over his mantelpiece.[140] The dramatic use of light in this painting anticipates Rungius' impressionist style, which would become a source of complaint from his patron, William Hornaday, the director of the New York Zoological Society.[141]

In 1921, after more than a decade of returning to Banff every summer, Rungius, assisted by his friend Simpson, bought some land on Cave Avenue in Banff, where his studio, "The Paintbox," was built the next year. Rungius was able to spend April to October in the Rockies every year until 1954.[142] His studio was a meeting place for artists, including J.E.H. MacDonald and W.J. Phillips,[143] and he also became friends of the young Banff artists Peter and Catharine Whyte.

Rungius liked to do landscape sketches outdoors, a technique of the Impressionist painters.[144] Over the course of his career, he did approximately 1,100 small oil panels *en plein air*,[145] possibly as reference sketches for his larger paintings of big game completed in the studio. He was fascinated by the portrayal of landscape on its own,[146] hoping to gain recognition in that field as well—a goal he undoubtedly achieved. His spontaneous sketches are remarkable for their use of light and colour; the paint is applied in broad strokes with great energy.[147] As a charter member of the Trail Riders club, Rungius was acquainted with John Murray Gibbon, who reproduced the artist's paintings in the CPR brochure *Resorts in the Rockies*, including the cover of the 1924 pamphlet with an oil of Mount Assiniboine and an antlered elk.[148]

BELMORE BROWNE

Belmore Browne, the American artist and mountaineer who made three attempts to climb Mount McKinley,[149] lived in Banff on Spray Avenue from 1921 to 1942 when he was a neighbour of Rungius.[150] The two men painted and camped together at Lake Louise in 1925.[151] Through the Trail Riders club, Browne also came in contact with Gibbon, who used his landscape paintings in *Resorts in the Rockies* (1929).[152] Both artists had a similar background in natural history. As a young man of 22, Rungius had gone on an expedition in 1902 for the American Museum of Natural History to paint, hunt, and prepare specimens of wildlife in the North.[153] In 1939, Rungius and Browne worked together on a moose diorama for the museum.[154] Occasionally, Browne would include wildlife in his landscapes, for example *Mountain Goats and Mt. Assiniboine*, but more often he painted a realistic panorama with the majestic mountains in the background.[155]

PETER AND CATHARINE WHYTE

Peter Whyte's portrayal of the mountain landscape was influenced by Rungius and Browne. As a teenager, Whyte had taken school courses and private lessons from Browne.[156] Two other landscape artists Whyte painted with at Lake O'Hara in Yoho National Park west of Lake Louise were J.E.H. MacDonald of the Group of Seven and Aldro T. Hibbard from New England. At Hibbard's suggestion in 1925, Whyte enrolled in the School of the Museum of Fine Arts in Boston to gain some academic training in painting, and it was there that he met and fell in love with Catharine Robb.[157] After they were married they built a log home near the banks of the Bow River in Banff over the winter of 1930–31[158] which would become, as Catharine explained in her lengthy letters to her mother, a meeting place for their friends and fellow artists.

Catharine and Peter painted the Rockies landscape together, sketching within calling distance of one another.[159] Catharine's nephew Jon Whyte relates a conversation with his aunt after Peter had died in which she had difficulty distinguishing her own unsigned sketches from Peter's.[160] Still, the two artists do exhibit general differences, as Jon Whyte explains.[161] Peter's work, always with a strong composition as a result of the influence of MacDonald, seems to project both a love for the landscape and a sense of foreboding in the mountains' looming shadows. Catharine, however, is

intrigued by all nature's changes in light, weather, and seasons; she particularly enjoyed painting large skies with special cloud effects. But like Peter's work, her paintings often show a tension between a peaceful foreground and a stormy background.

In 1933 when John Murray Gibbon was instrumental in organizing the Skyline Hikers of the Canadian Rockies under the sponsorship of the CPR, Peter and Catharine Whyte were directly involved. Peter and Carl Rungius were elected vice-presidents, while Catharine became an honorary member along with Byron Harmon and Walter Wilcox. Membership was based on having completed 25 miles of hiking in the Rockies.[162] Peter would eventually become president in 1937, a year after Rungius.[163] The Mount Assiniboine area was a popular destination for the Skyline Hikers. The camps of 1950, '60 and '68 were at Bryant Creek, but in 1973 the hikers were allowed to establish their base in the meadows near Mount Assiniboine.[164]

Assiniboine was a remote location, accessible only by a two-day ride, and this is probably the reason why Catharine's voluminous correspondence with her mother records only one visit there, in September 1937.[165] She describes how Chuck Millar, Erling Strom's packer, led them along Brewster Creek in hot sunshine on a perfect fall day amid yellow aspens. After spending a moonlit night at Brewster Creek cabin, they ascended Brewster Pass (Allenby Pass) the next morning, climbing on a rocky trail through the golden larches. The trail on the other side of the pass stayed high on the mountainside; Catharine compares the steepness of the terrain to Glacier National Park. After following a long valley, they gradually climbed to Og Pass before seeing magnificent Mount Assiniboine, higher than all the surrounding mountains. The sun was very hot as they rode the last two miles over the meadows to Assiniboine Lodge. After spending so long on horseback, Catharine was pleased to dismount, finally, and enjoy a welcoming cup of tea. She describes a hike the next day over Wonder Pass to a viewpoint 2000 feet above Marvel Lake, which was an incredibly deep blue that Catharine had never seen before. Peter did some sketching here, and the following day they both painted on a ridge, the Nublet, overlooking Magog, Sunburst, and Cerulean Lakes.

Inevitably, the weather changed from glorious sunshine to wintry snow that fell almost continuously for two days. Even though Peter and Catharine were forced to paint from the cabin porches, they were delighted. Peter declared that the snowy days were the best for painting. They had waited

in vain all winter for such a substantial snowstorm. Catharine comments on the trees bowed down under the snow, with the yellow needles of the larches showing through. After being shut in by the snow for a few days, they accompanied Erling Strom on a walk to Pat Brewster's camp at Sunburst Lake, but everyone had gone, apparently in a hurry because of the storm. Peter and Catharine returned to Banff in heavy snow after a cold week, complete with their sketches representing the two extremes of mountain weather.

Hospitality at Sunburst Lake:
Lizzie Rummel Entertains Hans Gmoser and Joe Plaskett

In the winter of 1938, a baroness named Elizabeth von Rummel left the family farm in the charge of her two married sisters and travelled to Banff seeking a challenge, perhaps the management of a guest ranch. What she did find in a store were photographs of Mount Assiniboine and Strom's camp. Intrigued, she later met Strom and agreed to work that summer as a hostess, chambermaid, and guide.[166] Lizzie, as she was affectionately called, journeyed on horseback over the same trails as Peter and Catharine Whyte, except that Lizzie climbed over Assiniboine Pass before she had her first, spectacular view of Mount Assiniboine—a stunning impression that would stay with her for the rest of her life.[167]

With her practical skills, cultured background, and tremendous empathy, Lizzie proved to be such an asset that Strom invited her back every summer until 1941, when she decided to strike out on her own again to manage Temple View Bungalow Camp. After a year there, she managed Skoki Lodge for seven years.[168] In 1950, when Pat Brewster offered to sell the Sunburst cabin to Lizzie, she seized the chance to return to her beloved Assiniboine and sold her life insurance policy and all her cattle at the family ranch to raise the money.[169] Lizzie ran Sunburst Camp for 20 years until she retired in 1970 at age 73. Comments in her guest books, preserved in the Whyte Archives, often reiterate her guests' appreciation of her good cooking, hospitality, warmth, and kindness. Although Lizzie never made much money from her modest tent camp adjacent to her log cabin overlooking Sunburst Lake, she gained the affection and loyalty of many guests, especially young climbers and artists who, in return for free accommodation, helped Lizzie around the camp with odd jobs.

One climber, Hans Gmoser, had come to Assiniboine for the ACC camp but could not afford the club's accommodation. Lizzie discovered his solitary camp in the bush and took him in, giving him free lodging so he could participate in the ACC climbs. Lizzie had a firm belief in his climbing ability, and over the years they became very close friends.[170] When Hans Gmoser and Franz Dopf made the first ascent of Sunburst Peak on the northeast face, August 18, 1953, Gmoser states in the guest book that he named the climb "Elizabeth Route" to honour the kindness of Miss Elizabeth Rummel.[171] Gmoser did become a very successful climber and owner of the world's first heli-skiing company, Canadian Mountain Holidays, but he never forgot Lizzie's kindness. He returned to stay at Sunburst many times, and for Lizzie's 80th birthday, Gmoser flew her by helicopter to his Cariboo lodge for lunch and in the afternoon took her on a glacier tour by air.[172]

Lizzie Rummel seemed to touch everyone she met at her Sunburst cabin, whether they were there just for tea or for a stay of a few days or several weeks. Shortly before her death in 1980, she was awarded the Order of Canada for inspiring others with her love of the mountains.[173] Lizzie and Erling Strom were captivated by Mount Assiniboine. Both dedicated their lives to allowing their guests a chance to experience this wonderful place, even though the monetary rewards were small. Ken Jones, the first Canadian guide in the Rockies, became a close friend of both Erling and Lizzie; every season Ken would turn up to help with maintenance, repairs, and the wood supply, totally free of charge.[174] When backpackers started hiking into the Assiniboine area in greater numbers in the 1960s, Lizzie and Erling petitioned the government to hire Ken as Park Warden to protect the environment, a position he held from 1967–74.[175]

One of the signatures in the guest book at Lizzie Rummel's Sunburst camp in September of 1952 and '53 was that of Joe Plaskett, a Canadian artist who grew up in Sapperton, B.C., near New Westminster. After completing a degree in history in 1939, Plaskett soon devoted all his energy to pursuing an artistic career. In his autobiography, *A Speaking Likeness*,[176] he describes his mentors Jock Macdonald and Lawren Harris, who included him as a young artist in their social gatherings in Vancouver. Harris also became a patron by purchasing Plaskett's paintings.

A third mentor was A.Y. Jackson, who extended his artistic influence not through philosophy or aesthetic ideas but by means of his personality and manner of working. Plaskett was impressed by Jackson's ability to achieve subtle effects in landscape paintings, and according to the younger artist,

his use of colour and brush strokes demonstrated the intrinsic nature of painting. Plaskett had the opportunity to study with Jackson at the Banff School in 1945,[177] and the next year he was invited to paint at the Onward Ranch in the Cariboo, along with Jackson.[178]

The Canadian landscape has always inspired Plaskett, even though for much of his career his studio has been in Paris, allowing him to travel extensively in Europe, northern Africa, Russia, and India. Many of his French paintings portray interior spaces, but in Canada he explored the Maritimes and Labrador, the Haida civilization of the Queen Charlottes, and Mount Assiniboine. With his fellow artists Jim Willer and Tak Tanabe, Plaskett experienced the same magic in the Queen Charlottes in the '80s that the three had experienced 30 years earlier by travelling over the mountain passes to Mount Assiniboine.[179] When Tak Tanabe became the head of the art department of the Banff School in the '70s, he persuaded a reluctant Plaskett to return to teaching for a term in 1972,[180] thus enabling another visit to Assiniboine and Plaskett's dramatic pastel of the mountain. On his many travels, Plaskett developed a technique of sketching in pastel, recording his impressions rapidly and with great immediacy.[181] He considers himself a Romantic artist who responds to the world through his emotions, and his admiration for artists such as Harris, Jackson, and J.E.H. MacDonald stems from their ability to portray the feeling and colour of the Canadian land.[182] Plaskett's comment in the Sunburst guest book indicates that the choice between European culture in Paris and the beautiful alpine landscape around Lizzie Rummel's camp was difficult.

The Banff School

A.Y. ...

The Banff School, initiated by A.C. Leighton, attracted two well-known artists as teachers in the 1940s: A.Y. Jackson and Walter J. Phillips. Jackson, who taught in Banff from 1943–47,[183] had made his first sketching trip to the Rockies in 1914, to the Yellowhead Pass with fellow artist Bill Beaty. They had been commissioned by the Canadian Northern Railway to paint construction camps as the tracks were being laid through the Rockies. Jackson's trip was filled with adventure, and he describes in his autobiography, *A Painter's Country*,[184] how they took chances by crossing glaciers unroped and

by relying on the braking power of sticks in their rapid descents on snow slopes. He learned practical lessons about survival in the mountains on limited rations and without a tent or blankets. The railway unfortunately went bankrupt and Jackson's sketches were not used. He also made the unhappy artistic decision that he was not attuned to painting mountains, and he burnt all of these sketches.[185]

In 1924 Jackson spent two months sketching with Lawren Harris in the Jasper area. He describes his thoughts about painting the alpine landscape in an essay in *The Canadian Forum*, "Artists in the Mountains." His main intent was not to produce photographic realism but to portray the "immense rhythmic movements"[186] of the mountains. The two artists found they were happiest sketching above the treeline in the undulating alpine meadows with carpets of flowers and small lakes; here they could see the mountains against the horizon without the interference of trees.

Jackson's niece Naomi Jackson Groves, in her book devoted to his drawings, *A.Y.'s Canada*, suggests he was more comfortable painting the rolling Laurentians than the sharp peaks of the Rockies.[187] Certainly, many more of his landscapes of eastern Canada survived than his mountain sketches. However, Jackson's autobiography and his essay on painting in the mountains clearly show that he thoroughly enjoyed the adventurous outdoor life in the Rockies. Even though on the 1924 trip he and Harris were often hiking 25 miles with elevation gains of 4000 or 5000 feet in one day, Jackson wrote "...there is no place where hardships can be so quickly forgotten, or where the artist will find more entrancing motives."[188] Jackson's drawings were an integral part of his creative process; after sketching quickly in oils to catch the effect of light, he would do a drawing to stress the rhythm and feeling of the landscape.[189] As Jackson was destroying drawings as late as 1968,[190] his preservation and gift of the drawing *Mt. Assiniboine Banff* (1943) to the National Gallery in 1974 is particularly significant.

... AND WALTER J.

Walter J. Phillips, trained in the English watercolour tradition, came to Canada with his wife in 1913 and settled in Winnipeg. Inspired by the beauty of the natural world, he concentrated on portraying the prairie landscape and the Lake of the Woods in watercolour and colour woodcut, a technique in which he became highly skilled. By 1941, however, his increasing interest in mountains as subjects led him to accept a position at Calgary's Provincial Institute of Technology and Art. At about

the same time, he started teaching in the summers at the Banff School, a post he would enjoy for 20 years.[191] Phillips was also a prolific writer, publishing his views in a regular column called "Art and Artists" in the *Winnipeg Evening Tribune*.[192] On the subject of mountains, Phillips spoke of his desire to climb above the monotonous green trees into the alpine meadows; his favourite locations were Lake O'Hara, Wenkchemna Pass, the Sunshine Meadows, and Mount Assiniboine.[193]

Unlike the Group of Seven, with their bold images of the uninhabited, rugged Canadian wilderness, Phillips preferred a more tranquil, friendly portrait of the natural world, one with a human presence.[194] His sensitive observations of nature's beauty were expressed in realistic images. He believed that colour had the greatest power to affect the viewer's emotions, but in order to produce its fleeting effects in the ever-changing light, the watercolour artist had to work quickly with great concentration.[195] Phillips' sketchbooks have survived, and they reveal the spontaneity of his work in the field, in contrast to the more polished paintings completed in the studio. He was highly accomplished in the tradition of English watercolours and generous in his praise of other artists who shared his interests and technique, commenting in particular that A.C. Leighton, in his draftsmanship, composition, and use of colour, represents perfection in this medium.[196]

Alpine Artists of Banff, Canmore, Calgary & Beyond

HERB ASHLEY

Herb Ashley, born in Banff in 1908 and educated there, was three years younger than another local artist, Peter Whyte. As teenagers both attended classes given by Belmore Browne and Mrs. Drummond-Davies.[197] Ashley was particularly interested in painting wildlife, and in the early '30s, Carl Rungius became a mentor, offering kind and helpful suggestions. At this time, Ashley was working as a labourer for the National Parks, and to supplement his income through commercial art, he taught himself showcard writing and sign painting. In 1937 a fortuitous meeting with Andrew King, a producer of show posters through his company Enterprise Show Print in Saskatchewan, led to a 20-year association for Ashley during which time he drew posters according to King's suggestions. Ashley continued to work for Parks as well, and by 1938 he was a Banff warden, becoming Chief

Warden in 1953. Part of his job was to observe, photograph, and sketch the park's plants and animals, thus happily combining his artistic talents and his love of the outdoors. After Ashley retired as Park Superintendent in 1967, he continued to concentrate on painting Canadian wildlife in oil, watercolour, and pastel.

HOLLY MIDDLETON

Holly Middleton, a resident of Banff, has devoted her life to the creation and teaching of art. Her first exhibition, at the age of 17 in 1939, was followed by formal instruction (1940–43) at the Winnipeg School of Art and the Banff School, where she took classes from A.Y. Jackson. She was also able to study with Walter Phillips in Calgary.[198] Her own teaching career began in 1948 when she was offered a place at the Banff School. She taught there for 13 summers between 1948 and 1971, allowing her the opportunity to work in the midst of the current artistic trends and to meet international artists, including William Townsend from England, who became a mentor.[199] A retrospective exhibit of Holly Middleton's work over the course of 50 years[200] shows a wide range of geography and subject matter, but two themes seem to predominate: human portraits in oil and the mountain landscape in watercolour. She likes to paint on location, and her images of the high alpine have a freshness and delicacy of colour.

ALICE SALTIEL-MARSHALL

Alice Saltiel-Marshall's studio is near the Bow River in Canmore, close to the mountains which have inspired much of her painting for more than three decades. Her enthusiasm and love of variety mean that her subjects are not limited to the alpine landscape; she has travelled and painted from coast to coast in Canada and in France. The high wilderness, however, entices her to undertake backcountry expeditions with her husband, Bill, a former warden with Alberta Parks. Recently they hiked from Sunshine Meadows to Mount Assiniboine, the same journey undertaken by the early explorers such as Wilcox and Outram. Alice creates images that are realistic in terms of geography, but these mountain paintings also express her deep affection for high alpine places. Through her sensitivity to the changing light, she captures the dynamic energy of the landscape, especially just before a storm or at dawn.

As a climber, photographer, and artist, Glen Boles has had the wonderful opportunity to enjoy exploring in the mountains for more than 30 years with the Grizzly Group, a name that refers not to the age of the climbers or their appearance but to an unexpected encounter with a bear.[201] Together they have hiked or skied to remote places in the Rockies, climbed many mountains, including first ascents, and absorbed over the years an intimate knowledge of the mountain landscape. Glen is famous for his photographs of these expeditions,[202] and his alpine expertise has led to co-authorship of two books about the Rockies: *Climbers' Guide to the Rocky Mountains of Canada—South* and *Place Names of the Canadian Alps*.

After retiring as a waterworks planner for the City of Calgary in 1991, Glen found time to join his love of the mountains with his artistic interests by creating remarkable drawings using pen and pencil on watercolour paper and by painting in acrylics. The incredible detail in his mountain images could even serve a practical purpose as a guide for aspiring climbers. In his careful observation of the subtleties of light and shadow falling on the natural forms of rock, ice, and water, Glen brings to life the powerful beauty of the mountains. Recently, he has published a volume of his photographs and drawings, *My Mountain Album*[:] *Art & Photography of the Canadian Rockies & Columbia Mountains*.

W.J. BRADLEY

W.J. Bradley was born and brought up in Banff, where her family had lived for two generations. Her memories of the family stories, especially those of her grandfather Chuck Millar, who started working as Erling Strom's horse packer in 1938,[203] give her a great sense of Banff tradition. As well as transporting guests and supplies into Assiniboine from Banff, Millar would lead horse trips to the lakes nearby. His favourite excursion was to Elizabeth Lake and to a wonderful vantage point nearby, now known as Chuck's Ridge, where one has a spectacular view into the surrounding valleys, including Ferro Pass.

W.J. Bradley's art combines her feeling of belonging with an exhilaration in the mountain landscape. Her greatest joy is to paint outdoors and to try and capture the fleeting moments of beauty. Some of her favourite places in the mountains include Lake O'Hara, Bow Lake, and Mount

Assiniboine, but she has ventured beyond the Rockies to the landscapes of the Queen Charlottes, northern British Columbia, and the Yukon. Through her organization Artistic Journeys, W.J. Bradley acts as a mentor for other artists who wish to be inspired and challenged by painting outdoors in the midst of captivating landscapes.

ZELDA NELSON

Another member of Canmore's lively artists' community is Zelda Nelson, originally from Saskatoon but one who has been drawn westward, like Walter Phillips, first to Calgary and then finally to live in the midst of the mountains. Zelda has studied at the Banff Centre, and she is inspired in her approach to the landscape by the Group of Seven. Her goal is to express her passionate feelings through her paintings, and she often works on location in order to enhance a sense of spontaneity. Zelda has focused mainly on the alpine landscape, with a recent painting excursion to Lake of the Woods. Two of her favourite mountain places are Lake O'Hara and the Assiniboine area, with Mount Assiniboine in particular having a powerful spiritual influence on her. She describes the energy released when the rising sun brings the first colours of dawn to the peak of Assiniboine while the lower regions are still in shadow.[204] Zelda projects the splendour and power of the mountain landscape in strong shapes and rich colours.

DONNA JO MASSIE

Donna Jo Massie is another artist living and working in Canmore, close to the inspiration for her mountain watercolours. With a background in education, she combines her love of art and nature by teaching adults how to paint the alpine landscape through workshops. Her *Rocky Mountain Sketchbook* is an encouraging introduction for those willing to experience the joy and challenge of sketching outdoors. Donna Jo, like A.C. Leighton and Walter Phillips before her, carries her watercolour box on expeditions into the backcountry. Her images of Assiniboine reveal the clear, solid mountain shapes beside the blazing colours of the fragile larches—the enduring elements in the midst of the changing seasons. Donna Jo's positive approach to teaching is reflected in her vibrant watercolours.

MIKE SVOB

Over the last 25 years, Mike Svob, who lives in White Rock, B.C., has produced a significant body of work in watercolour, acrylic, and oil, including large murals throughout North America. As a past president and senior member of the Federation of Canadian Artists, Mike shares his knowledge through teaching workshops and publishing books on the techniques of the professional artist. His impressionist style is characterized by the use of strong colours. Mike's vibrant Assiniboine landscapes are the result of several hiking expeditions with his family, including one occasion when they were charged by a grizzly bear in Assiniboine Pass.

JEAN PILCH

Another Alberta artist is Jean Pilch, from Calgary, who portrays the landscape in both acrylic and pastel pencils. She, too, likes to hike in the mountains, taking reference photographs for her precise, realistic paintings completed in the studio. She has a keen eye for an effective composition, juxtaposing the ephemeral elements of water and foliage with the permanence of rock. Her favourite places in the Rockies include the Sunshine Meadows and Mount Assiniboine; her portraits capture in every detail the wild beauty of the high alpine landscape.

JEAN GEDDES

Now living in Calgary, Jean Geddes has pursued her artistic interests since childhood. She paints most frequently in oil because she enjoys the challenge of this medium. Her subject matter often includes mountain landscapes, but her regular travels throughout North America produce a wide variety of photographs which she develops into paintings in her studio. Her exploration of the remote backcountry on the Continental Divide east of Mount Assiniboine was made possible by a helicopter tour, and she has created a remarkable image of Aurora Mountain reflected in an alpine lake, a beautiful place which few people ever see. As well as a professional artist, Jean is a critic and juror, and she teaches advanced classes in painting.

Simon Camping, originally from Holland, lived for many years in Calgary but moved to the West Coast in 1981. He returns to the mountains, however, to find subjects, having made the journey to Assiniboine for the last 20 seasons. His acrylic paintings done in the studio from photographs are exact in their shapes and colours; the wonder lies in his ability to isolate a moment of still, shimmering beauty in a reflection or new fallen snow.

Mount Assiniboine: World Heritage Site

Mount Assiniboine is recognized by the United Nations as a World Heritage Site. This magnificent place will be preserved for the recreation and inspiration of Canadians and the entire world. Many have attempted to define Mount Assiniboine: the explorers found their way to the base of the mountain by travelling along river valleys and over high passes; the first climbers overcame what was thought to be an insurmountable challenge by standing on the summit of this formidable peak; early trail riders and hikers came to enjoy a wilderness adventure in a landscape of lakes and alpine meadows surrounded by awesome mountains; and the artists endowed with exceptional powers of observation and expression tried to capture on paper, board, and canvas the scale, the energy, and the shifting light and shadow of the Mount Assiniboine area.

These artists of the Canadian alpine landscape have special qualities. They are willing to undertake the arduous journey into the backcountry and endure the physical challenges of distance, perilous trails, and threatening weather. Often sketching outdoors, they can detect the forms and rhythms of the mountains. Their sensitivity to colour and value enables them to transfer their feelings about this enormous landscape to a comparatively small canvas. Each in their own way, these artists have defined Mount Assiniboine and the surrounding mountains and meadows by offering us a unique glimpse of the changing moods of this wonderful place.

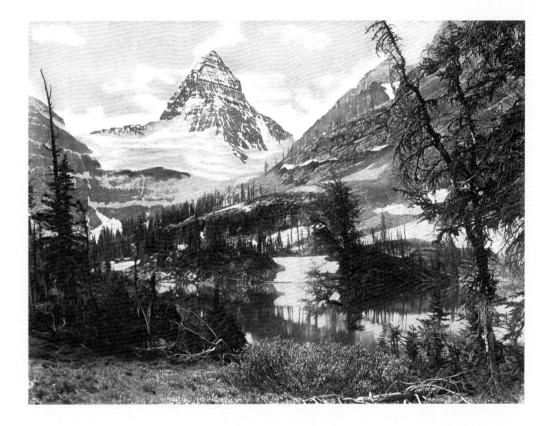

Walter Wilcox

PHOTOGRAPH OF SUMMIT (SUNBURST) LAKE NEAR MOUNT ASSINIBOINE, 1895
WHYTE MUSEUM OF THE CANADIAN ROCKIES (V85/NA66-555).

ASSINIBOINE FROM THE NORTHWEST

The majestic mountain, which is a noble pyramid of rock towering above snow fields, was clearly reflected in the water surface. Such a picture so suddenly revealed aroused the utmost enthusiasm of all our party, and unconsciously everyone paused in admiration while our horses strayed from the trail to graze. Continuing once more, we traversed some open places among low ridges covered with beautiful larches. We passed through a delightful region which descended gently for half a mile to a treeless moor, where we pitched camp. Behind us was a clump of trees, before us Mt. Assiniboine, and on our left a lake of considerable size, which washed the very base of the mountain and extended northwards in the bottom of a broad valley.

—WALTER WILCOX, *The Rockies of Canada*, 81

WALTER J. PHILLIPS

Mount Assiniboine from Sunshine Meadows, 1945

WATERCOLOUR ON PAPER, 28.7 × 37.8 CM
COLLECTION OF THE WHYTE MUSEUM OF THE CANADIAN ROCKIES

Mount Assiniboine looms high in the distance, dominating this scene painted near the lodge from Jones Hill Benches looking over the Nublet. Phillips' portrayal of this magnificent peak higher than the surrounding landscape is reminiscent of the early descriptions by Wilcox and Outram on their first sight of Assiniboine from Sunshine Meadows. This is a finished work, possibly done in the studio from a field sketch. The sloping diagonals in the foreground and in the middle balance the verticality of the summit. Our eye moves from the sharp rocks of the talus slope at the front of the painting and across the undulating grass, clumps of trees and bushes, and the rounded shape of the Nublet to rest, finally, on the sharp edges of Assiniboine's peak. Phillips' vibrant colours contrast the warmth of the vegetation that has taken hold on the hillside with the lighter tones of the summit soaring into a hazy sky. In a single image, Phillips captures the fragility and solidity of the alpine landscape.

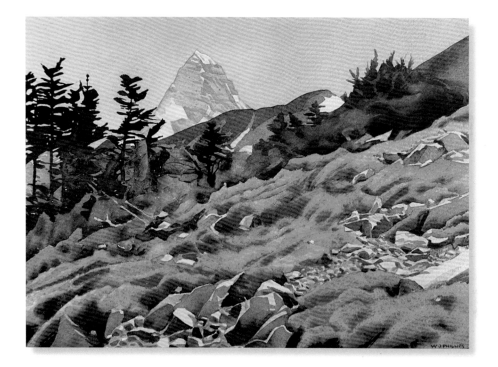

A. Y. Jackson

Mount Assiniboine, Banff, 1943

GRAPHITE ON WOVE PAPER, 22.7 × 30.0 CM
NATIONAL GALLERY OF CANADA, OTTAWA
GIFT OF THE ARTIST, KLEINBURG, ONTARIO, 1974
COURTESY OF THE ESTATE OF THE LATE DR. NAOMI JACKSON GROVES

A.Y. Jackson's pencil sketch of Mount Assiniboine from the northwest, in the vicinity of Sunshine Meadows, perhaps near Howard Douglas Lake, is one of his few mountain sketches to have survived. We can discern Jackson's notations, with the numeral 2 and the use of x, perhaps to remind him of colours or values for a later painting. If a more finished work were to have been produced, it has not yet surfaced. In this spontaneous sketch, we can see the artist at work, but the quickness of the pencil strokes does not preclude Jackson's practised eye capturing the distinctive shapes of the distant mountains, especially the alluring peak of Assiniboine. The foreground boulders anchor the composition, and their shapes are repeated on the horizon, while the rounded hill in the middle of the sketch provides a contrasting shape.

Mt assinibone Banff
Aug 9

CARL RUNGIUS

Mount Assiniboine, n.d.

OIL ON CANVAS, 22.9 × 27.9 CM
COLLECTION OF GLENBOW MUSEUM

Rungius presents an exhilarating view of Mount Assiniboine from Sunburst Lake. When Walter Wilcox climbed from Wedgwood Lake past Cerulean Lake in 1895, his first, wonderful view of Assiniboine was from this location. The guests at Sunburst Camp run by Lizzie Rummel awoke to this amazing scene every morning. Rungius obviously painted on location, indicated by the four thumbtack circles in the corners of the canvas. He has captured a few moments of perfection on a summer's morning as the sunshine brings light and colour to the landscape. The sloping lines of Mount Magog and Sunburst frame the towering pyramid of Assiniboine. The level glacier below the peak is balanced by the brilliant blue of Sunburst Lake in the foreground. Rungius' masterful use of light and colour, as well as his deft strokes, in the trees for example, give the image great vitality.

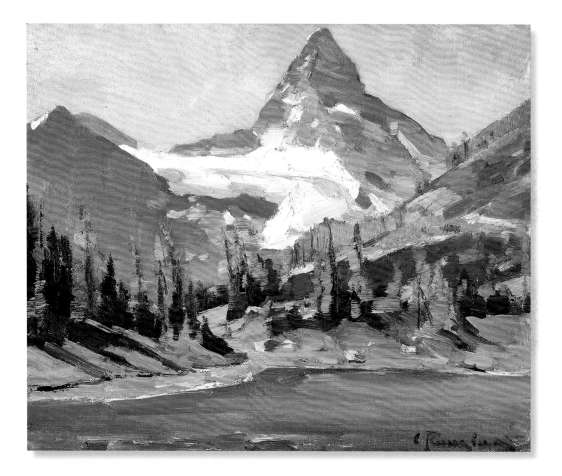

MIKE SVOB

Glacier on Assiniboine, 2005

OIL ON PANEL, 30.5 × 40.6 CM
PRIVATE COLLECTION OF THE ARTIST

In Mike Svob's image, the sunlight falls on Mount Assiniboine's west face and the glacier, making the broad band of ice, stretching three-quarters of the width of the painting, the central focus. The brilliant white of the illuminated glacier contrasts with the icy blue shadows, while the deep purples of Mount Magog's shoulder on the left balance the red, sunlit slopes of Sunburst Mountain extending down to Sunburst Lake. The intersecting diagonals of the mountains closest to the viewer help to form two triangular shapes, with the third triangle rising above in Mount Assiniboine, its peak disappearing beyond the frame. Colourful clouds in yellows and pinks hang behind Assiniboine's soaring pyramid. The alpine landscape is not sombre or forbidding in Mike's painting; his vibrant colours and energetic style captivate the viewer's eye.

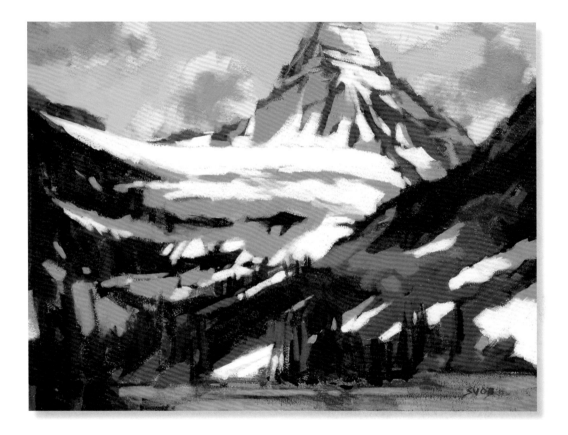

BELMORE BROWNE

Mountain Goats and Mt. Assiniboine, 1947

OIL ON CANVAS, 45.0 × 59.0 CM
COLLECTION OF THE WHYTE MUSEUM OF THE CANADIAN ROCKIES

Browne has placed the mountain goats in their natural habitat on a rocky ledge above a precipitous cliff. The painting conveys a great sense of height as the goats look out into airy nothingness, higher than the mist in the valley and the soaring bird. Mount Assiniboine rises in the distant centre of the painting, directly over the head of the goat in the foreground. Browne appears to have placed the goats on an east-facing ledge above Sunburst Lake and to have moved Assiniboine back, giving the impression that the peak is farther away. The diagonal ledge with the warm ivory-coloured fur of the goats dramatically bisects the painting, providing a sharp contrast to the distant, snowy peaks of Mount Magog on the left and of Mount Assiniboine towering above the mist.

ARTHUR P. COLEMAN

Tepee, Assiniboine Camp, 1920

WATERCOLOUR OVER PENCIL, 17.4 × 12.7 CM
WITH PERMISSION OF THE ROYAL ONTARIO MUSEUM © ROM

Arthur Coleman records his visit to the Assiniboine area with a visual journal; each of his four charming watercolours appears to have been painted from nature. He has signed, dated, and described each image, employing precisely the same dimensions. A watercolour painter since childhood, Coleman travelled extensively in the mountains, and he used his artistic talent to capture the feeling of the alpine landscape. The tepee is located beside Lake Magog, with the majestic presence of Sunburst Mountain towering in the background, while the door of the tent looks toward Mount Assiniboine. Smoke drifts gently up toward blue patches among the clouds, and the morning light reveals this idyllic scene of man's exploration in the mountains. The gentle curves of the shoreline and stands of trees in the middle of the painting balance the vertical shapes of the tepee and Sunburst. Coleman places a startling patch of red, possibly low bushes, at the front of his watercolour to catch the viewer's eye.

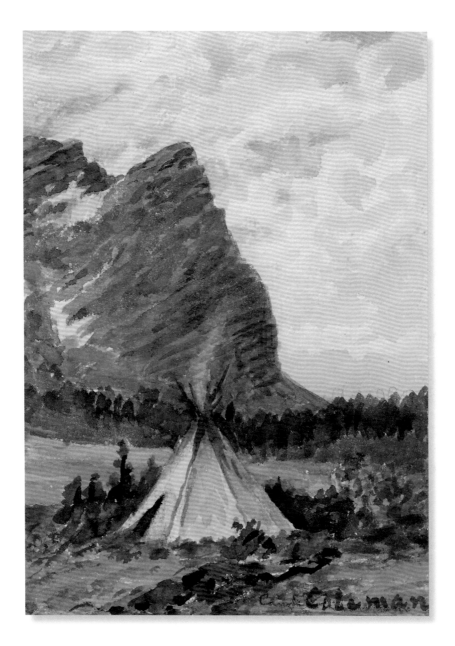

SIMON CAMPING

Winter, Sunburst Peak, 2005

ACRYLIC ON WATERCOLOUR PAPER, 75.9 × 55.3 CM
PRIVATE COLLECTION

The stunning effect of the morning light is immediately apparent in Simon Camping's view over the end of frozen Sunburst Lake and up to snowy Sunburst Peak towering overhead. The painting is filled with the dazzling white of the undisturbed snow in the sunshine. It hangs on the ledges and in the crevices and forms clumps on the branches, all portrayed in such detail that one can almost touch it. The whiteness is balanced by the dark evergreens, which in turn point to the reddish rock above. A delicate shape has been traced on the level expanse of snow in the foreground. Camping has created an image of such purity and stillness that it seems to be the essence of the alpine winter landscape.

ALICE SALTIEL-MARSHALL

Elizabeth Lake, 2007

OIL ON BOARD, 30.5 × 40.6 CM
PRIVATE COLLECTION OF JANE AND BRYAN GOOCH

Elizabeth Lake, named after Lizzie Rummel, is tucked into the base of the Nub, not far from Lizzie's camp at Sunburst Lake. One can imagine Lizzie coming to this small lake on one of her evening walks, possibly following the trail past Cerulean Lake and descending to the meadows surrounding the outlet stream. Another approach is down the steep scree slopes from the summit of the Nub, but the effect is the same: one finds a place of peace and idyllic beauty, an enticement to linger. Alice Saltiel discovered this wild garden as she hiked over the ridge from Cerulean Lake on an August morning. Her painting captures the energy of the alpine meadow in the vibrant colours of the fireweed blossoms and leaves clustered in the foreground. Over the flowers and through the opening in the trees, the eye follows the delicate larches to the soft blue of the lake. Alice's painting recreates the warmth and serenity of Elizabeth Lake on a summer's day.

CATHARINE WHYTE

Near Assiniboine, n.d.

OIL ON CANVAS, 27.8 × 35.3 CM
COLLECTION OF THE WHYTE MUSEUM OF THE CANADIAN ROCKIES

Catharine possibly sketched this scene from the Niblet above Sunburst Lake and looking past the shoulder of Sunburst Mountain, on the right, to the peak of Assiniboine rising beyond the frame. The wedge-shaped summit of Mount Magog is in the distant centre. The fall sunlight shining on the golden larches creates the central focus of the painting, even screening the dominant spire of Assiniboine. Catharine places the larches between a line of massive, dark boulders and the shadowed mountain shoulders beyond, emphasizing the brilliance and fragility of the trees in this rocky landscape. One has a sense of the vertical with the branches reaching up to the peak of Assiniboine, but Catharine provides a balance by, characteristically, using the three bands of horizontal cloud to repeat the line of rock in the foreground. She delights in the microcosm of alpine beauty in the midst of towering giants.

PETER WHYTE

Magog and Sunburst Lake, n.d.

OIL ON CANVAS, 27.4 × 35.2 CM
COLLECTION OF THE WHYTE MUSEUM OF THE CANADIAN ROCKIES

While Catharine chose to paint the peak of Assiniboine soaring into the sky, Peter from a vantage point nearby concentrates on Sunburst Lake, directly below, and Lake Magog below the glacier on Mount Assiniboine. The symmetry of the lakes and the glacier intersected by the sloping diagonals of the mountains is more important in this painting than the great summit. The glorious afternoon sunlight touches the landscape, illuminating the glacier, the larches between the lakes, and the meadow in the foreground. Peter has achieved a spontaneity in his sketch as he worked quickly to capture the effects of light on a beautiful autumn afternoon in the mountains.

JEAN PILCH

Jewels at My Feet, 2005

PASTEL ON PAPER, 29.2 × 40.6 CM
PRIVATE COLLECTION

Jean Pilch's glorious panorama from the Nub presents the landscape in incredible detail. Below are the three lakes, Magog on the left, Sunburst in the middle, and Cerulean on the right. The dark face of Sunburst Mountain looms over Cerulean and Sunburst Lakes, while, behind, the majestic spire of Assiniboine soars into a blue sky. Snow lingers in the gullies and lies on the ground on top of the Nub, a summit of 2748 metres accessible by a strenuous scramble. Her sensitive control of light gives this pastel tremendous vitality. The mountains are delineated in careful gradations of light and shadow, and all the blue tones of sky, rock, and water are subtly contrasted with the forested ridges. The precision of line and colour is particularly significant when one considers the nature of the medium. The three lakes gently curving around the mountains' bases reflect the imposing vertical faces rising from their shores. Jean Pilch's light-filled landscape contrasts the placid lakes and challenging ramparts, the tranquility and majesty of the alpine.

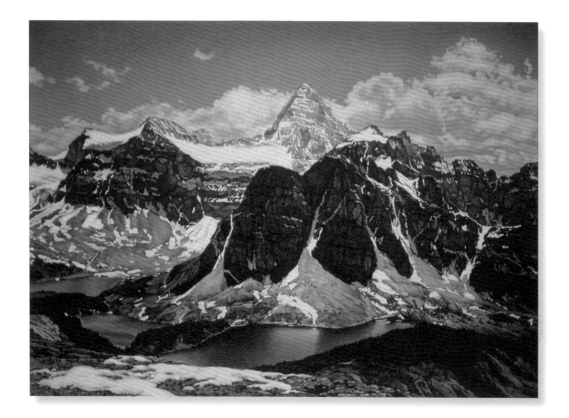

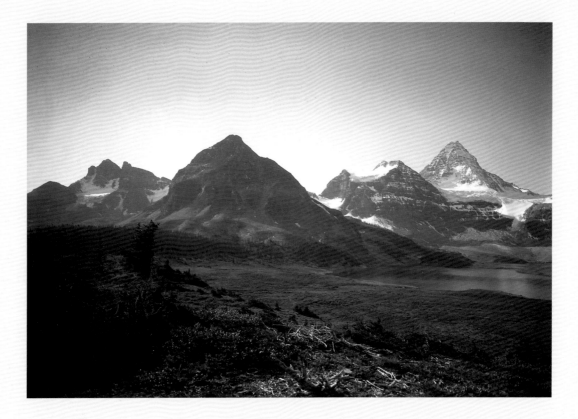

Byron Harmon

Photograph (l to r) of The Towers, Naiset Point, Mount Magog, Mount Assiniboine and Magog Lake, n.d. The Whyte Museum of the Canadian Rockies (v263/na71-668)

EAST OF ASSINIBOINE

We took our lunch…and went over Wonder Pass & down to a lookout point where we could get a marvelous view. It was lovely when we got there at noon. About two thousand feet directly below us was Marvel Lake, a deep, unbelievable indigo blue. I've never seen a lovelier color….We also saw the back side of Assiniboine and Mt. Aye and Eon, the later [sic] a very high mountain with a beautiful glacier falling below to two other lakes—Gloria and Terrapin. These lakes were turquoise in color, as bright and light in color as Marvel was deep & dark and yet they lay just above Marvel in the valley.

—CATHARINE WHYTE, Letter, September 30, 1937.
The Whyte Museum of the Canadian Rockies, M36 102

Arthur P. Coleman

Tower Mountain near Assiniboine, Morning, 1920

WATERCOLOUR OVER PENCIL, 12.7 × 17.4 CM
WITH PERMISSION OF THE ROYAL ONTARIO MUSEUM © ROM

Coleman painted this peaceful scene from the meadow beside Gog Lake, just revealing its quiet reflections in the lower right corner. The morning sunlight shines on the branches of trees in the foreground and brings colour to the plants growing near their base. The lines of the trees and the bare trunk lead the viewer's eye to the three towers above, which catch the brilliant morning light in delicate shades of red. Coleman's watercolour reveals the stillness and beauty of the alpine landscape with its meadows and lakes presided over by awesome mountains.

Arthur P. Coleman

Tower Mountain near Assiniboine, Evening, 1920

WATERCOLOUR OVER PENCIL, 12.7 × 17.4 CM
WITH PERMISSION OF THE ROYAL ONTARIO MUSEUM © ROM

The warm glow of The Towers in the setting sun dominates this watercolour. Coleman's perspective appears to be from the meadows below Gog Lake, looking toward the massive bulk of the mountain, which almost fills the entire frame. Only thin bands of green meadow and blue sky appear, while the red turrets rise magnificently out of the snow covering the talus slopes. Coleman expands this image of The Towers horizontally to emphasize their powerful presence.

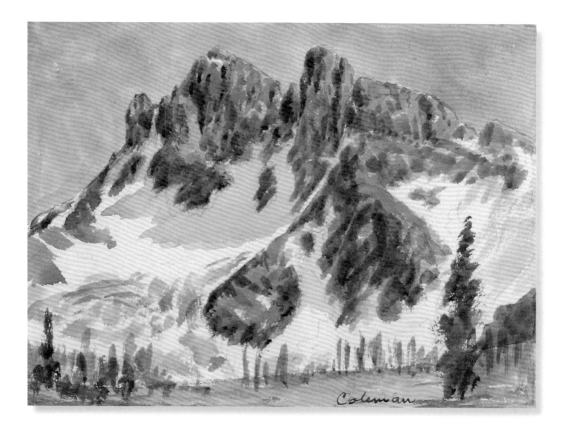

FRANK PANABAKER

Mount Assiniboine (The Towers), c. 1925

OIL ON CANVAS, 26.5 × 34.0 CM
COLLECTION OF THE WHYTE MUSEUM OF THE CANADIAN ROCKIES

Panabaker painted this dramatic image of The Towers from the meadows just below Gog Lake, east of the present Naiset Huts, originally constructed as Wonder Lodge by A.O. Wheeler. This wintery scene is reminiscent of his trip to Assiniboine in the third week of September, which he describes in *Reflected Lights*. The storm clouds piled against the stone spires may presage more snow. The morning light, however, shines through a small blue opening in the sky, warming the rock on the eastern faces of The Towers and irradiating the meadow and trees below. These glowing patches of sunlight provide warmth in an otherwise cold scene. The meandering stream and converging lines of trees lead the eye from the foreground toward the majestic towers. The energetic brushstrokes in the threatening sky contrast with the gentle pools of sunshine. The landscape is at once forbidding and welcoming.

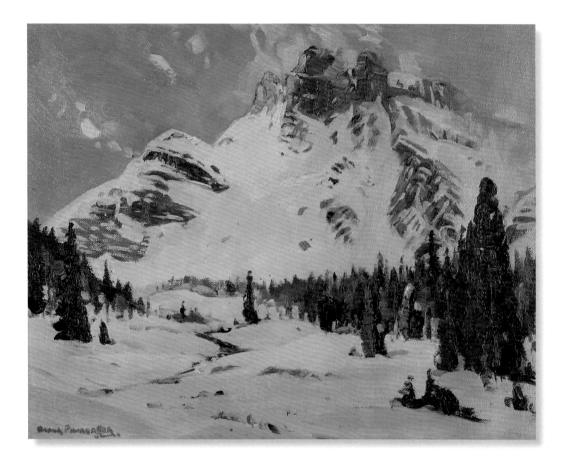

BARBARA LEIGHTON

The Towers, Mt. Assiniboine, n.d.

WOODCUT ON PAPER (32/100), 31.5 × 37.0 CM
COLLECTION OF THE WHYTE MUSEUM OF THE CANADIAN ROCKIES

Barbara Leighton has created a vibrant image of The Towers in the warm afternoon sun. Her perspective is from the shore of Gog Lake at the point where the lake narrows in the centre. The eye is drawn across the calm expanse of the lake in the foreground to the dramatic vertical rise of The Towers with their crenellated spires. Leighton has used a very demanding technique involving coloured woodblocks; each colour is applied with individually carved shapes which fit precisely together to form the complete painting. The complexity of her image is apparent in the different values, with the darker tones balancing the lighter in the foreground meadow and in the immense talus slopes below The Towers. The painting culminates in the glowing, reddish peaks soaring overhead in the summer sunshine.

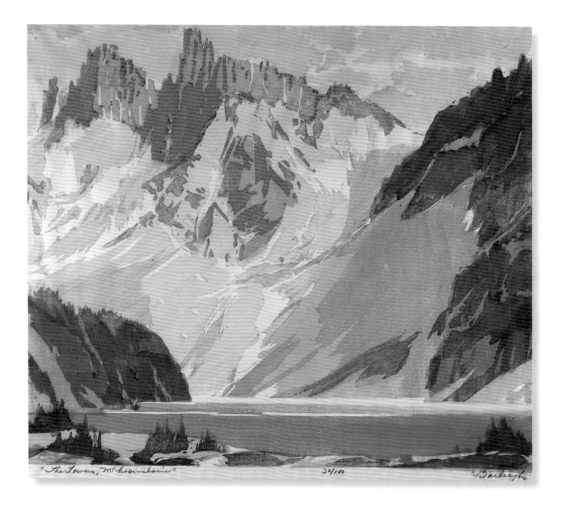

"The Towers, Mt Assiniboine" 32/100 Burleigh

DONNA JO MASSIE

Trail to The Towers, 2001

WATERCOLOUR ON PAPER, 35.6 × 71.1 CM
PRIVATE COLLECTION

Donna Jo's vantage point for this image of The Towers is from a meadow east of the Naiset Huts. Her watercolour shows the formidable strength of the peaks, etched firmly against the sky and resembling the battlements of a castle. The autumn sunshine illuminates the grove of brilliant larches just beyond the gently rolling meadow in the foreground. The rich colours of the alpine vegetation are a dramatic contrast to the distant, austere towers dominating the landscape. The interplay of line and colour between the natural foliage and the stone ramparts gives this painting tremendous vitality.

92

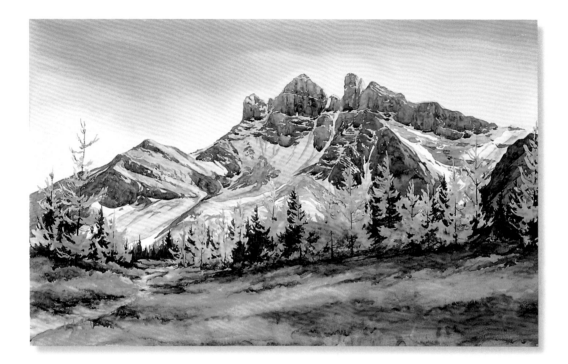

MIKE SVOB

The Towers, 2003

OIL ON PANEL, 30.5 × 40.6 CM
PRIVATE COLLECTION OF TIM AND LESLEE WAKE

Mike Svob's perspective from the Wonder Pass trail presents a dramatic close-up of The Towers, brilliant in the morning sunlight against a dark sky. He omits the long talus slopes stretching down to Og Lake and concentrates instead on the spectacular colour contrasts in the spires, between the warm tones of the illuminated rock and snow and the rich, dark shadows. Vivid planes of colour shape the crumbling rock faces in an impressionist style, giving the painting great energy.

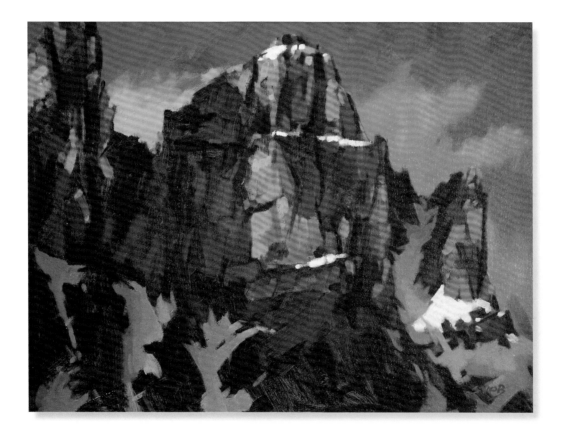

WALTER J. PHILLIPS

Assiniboine, 1946

WATERCOLOUR ON PAPER, 30.5 × 23.0 CM
COLLECTION OF GLENBOW MUSEUM

This view of Assiniboine looking across the meadows from a vantage point high on the side of Mount Cautley is from one of Phillips' sketchbooks. Even though he was painting the scene on location, the greater freedom is combined with Phillips' characteristically careful composition. The meadows and the peaks are given equal emphasis, and they complement one another: the rolling contours in the foreground rise to a low triangle which is repeated in the distant peak of Assiniboine on the right. On the left, we see The Towers from a different angle. The colours are typical of Phillips' delicacy and realism, with the soft greens in the valley giving way to the mauves and browns of the mountains. The sketch has a freshness and softness, juxtaposing the meadows and the mountains.

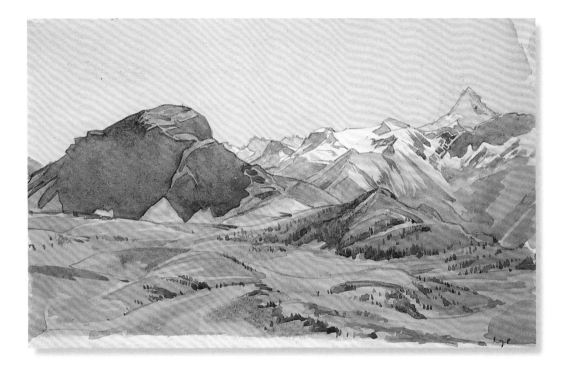

BELMORE BROWNE

Rainy Day at Marvel Lake, 1934

OIL ON CANVAS, 30.5 × 40.6 CM
COLLECTION OF GLENBOW MUSEUM

Browne appears to have painted this scene from the Wonder Pass Trail, overlooking the south end of Marvel Lake. One can reach Marvel Pass by skirting the lake and climbing to the meadows between Marvel Peak on the left and Mount Gloria on the right. Walter Wilcox set out this way on his epic circuit of Mount Assiniboine in 1895, and on the other side of Marvel Pass he encountered the charred remains of a forest. Almost 40 years later, Browne portrays stark, blackened poles in the foreground, the result, according to Barb Renner, of a fire in 1921. In contrast, just beyond is the deep blue of the lake, a colour Catharine Whyte found incredibly beautiful. Past the lake the forest is green once again, leading the eye to the alpine meadows above. Despite the rain and the burnt timber, the landscape has a serene beauty in the natural cycles of fire and regeneration.

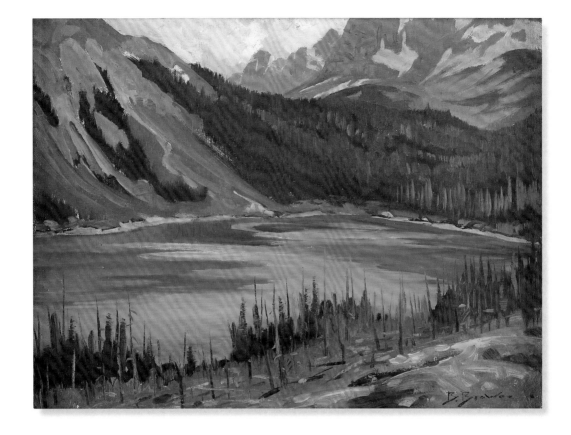

HERB ASHLEY

Marvel Lake, 1949

OIL ON CANVAS, 53.5 × 63.5 CM
COLLECTION OF GLENBOW MUSEUM

This vibrant panorama of the mountains enclosing Marvel Lake was painted in the morning sunshine possibly from a ledge high above the Bryant Creek Trail, not far from the warden cabin where Ashley may have been stationed at the time. The lake rests like a turquoise jewel set between Marvel Peak on the left, Mount Gloria in the centre, and Aye Mountain on the distant right. The waterfall draining Lake Terrapin is just visible, as a tiny speck at the far end of Marvel Lake. The shapes of the mountains, with massive blocks piled one on another, are repeated in the foreground jumble of boulders. Ashley further unifies his landscape by using similar tones of yellow and green in the meadow closest to the viewer and in the lower slopes of the distant mountains. The whole painting is suffused with great energy, a perfect summer morning in the mountains.

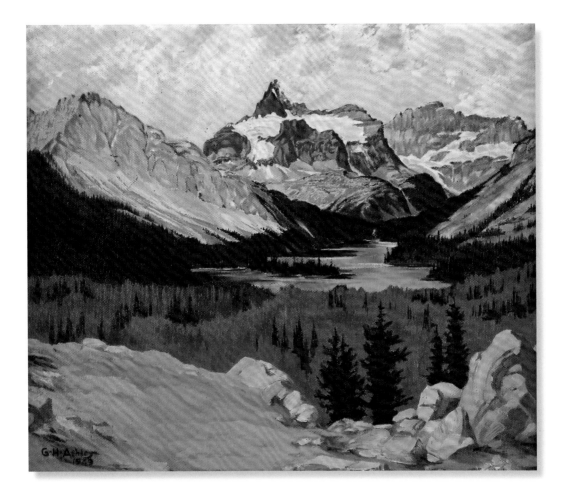

JEAN GEDDES

Aurora's Mirror, near Mount Assiniboine, 2006

OIL ON LINEN, 76.2 × 76.2 CM
PRIVATE COLLECTION OF THE ARTIST

Aurora Mountain, southeast of Mount Assiniboine, has the name of the Roman goddess of the dawn. The lake in the painting, the mirror, is also called Aurora and is situated across the valley to the west in Marvel Pass. Both mountain and lake are on the Continental Divide, the border between British Columbia and Alberta. Jean Geddes presents the reflected image of Aurora Mountain on a summer morning with the western faces still in shadow. The brilliant green of the rolling, alpine meadow in the centre of the painting is in contrast to the magnificent, looming presence of the mountain above and below. The still, watery reflection is wonderful, softening the sharp lines of the steep gullies and folded rock on the mountain's slopes. Jean Geddes' realistic landscape expresses at the same time a sensitivity to a special moment — the enduring mountain is caught in the ephemeral mirror of the lake.

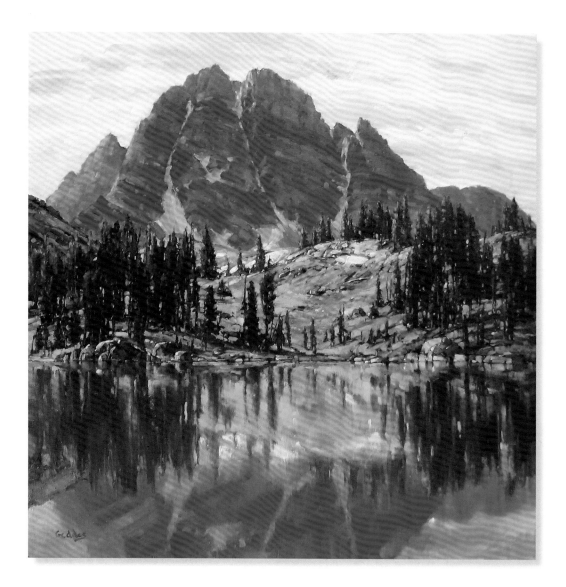

A.C. LEIGHTON

Mount Assiniboine, n.d.

OIL ON LINEN, 66.3 × 76.6 CM
ART GALLERY OF ALBERTA COLLECTION
PURCHASED IN 1989 WITH FUNDS FROM
THE ART ASSOCIATES OF THE EDMONTON ART GALLERY

Leighton's view from the northeast shows the double summit of Assiniboine soaring above low cloud and horizontal bands of mist into an expanse of blue sky that takes up half of the canvas. Far above, an ephemeral arch of cloud floats over Assiniboine, drawing the eye even higher. Leighton's perspective is spectacularly high, almost an aerial view; we see the exhilarating landscape of peaks and glaciers rising out of the morning mists soon to be dissipated by the sunshine to reveal the mountains' precise shapes. Leighton's clear, crisp palette captures the powerful presence of peaks emerging from the shrouded world below. The painting has a sense of mystery because of what cannot be seen, but Leighton portrays Mount Magog directly in front of Assiniboine. The artist's vantage point was possibly about ten miles away, at an elevation of around 8500 feet on the side of Cone Mountain above the Bryant Creek Trail.

Peter Whyte

MOUNT ASSINIBOINE

Mount Assiniboine, especially when seen from the north, resembles the Matterhorn in a striking manner. Its top is often shrouded in clouds, and when the wind is westerly, frequently displays a long cloud banner trailing out from its eastern side.

—WALTER WILCOX, *Camping in the Canadian Rockies*, 178

Arthur P. Coleman

Mount Assiniboine, Morning, 1920

Watercolour over pencil, 17.4 × 12.7 cm
With permission of the Royal Ontario Museum © ROM

In this small painting, Coleman effectively portrays the monumental beauty of Assiniboine's peak and glacier in the morning light. The shoulder of Mount Magog, the artist's vantage point, is still in shadow; and the striking contrast between the darker, diagonal slopes of Magog and the illuminated peak emphasizes the vertical summit soaring into a cloudless blue sky. Coleman's watercolour gives us a dramatic view of the northwest ridge made famous in 1901 when James Outram and his guides courageously descended for the first time.

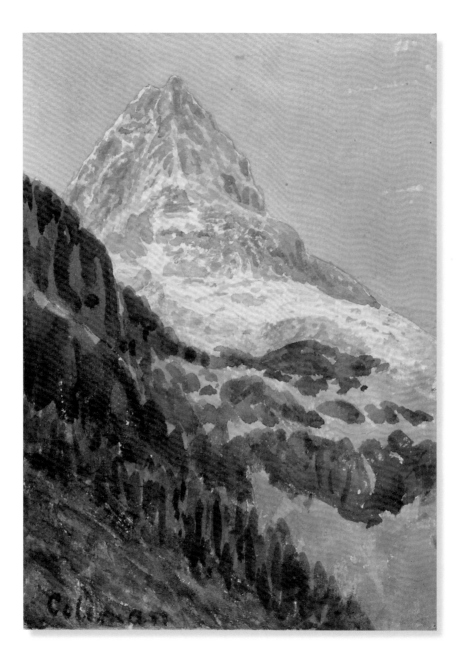

Carl Rungius

Mount Assiniboine and Lake Magog, n.d.

OIL ON CANVAS, 22.6 × 27.9 CM
COLLECTION OF GLENBOW MUSEUM

Rungius has done this small oil sketch of Mount Assiniboine from the lakeshore at a spot fairly close to the base of the mountain so that the peak appears foreshortened. The morning light shines on the east-facing slopes of Wedgwood Peak, while Mount Magog's snowy ledges are still in shadow. Although the snow is gone from the lakeshore in the foreground, the lake still has ice, and the chute coming down from the glacier is snow covered. The peak, framed by the diagonal shapes of Magog and Wedgwood, is painted in white and muted shades of brown and blue, while, directly below, the point of land jutting into the lake is a strong contrast with the vivid colours of spring vegetation. The painting has great energy in the way Rungius quickly applies broad brush strokes, moulding the snow in the gullies and giving a dappled, impressionistic effect to the foreground.

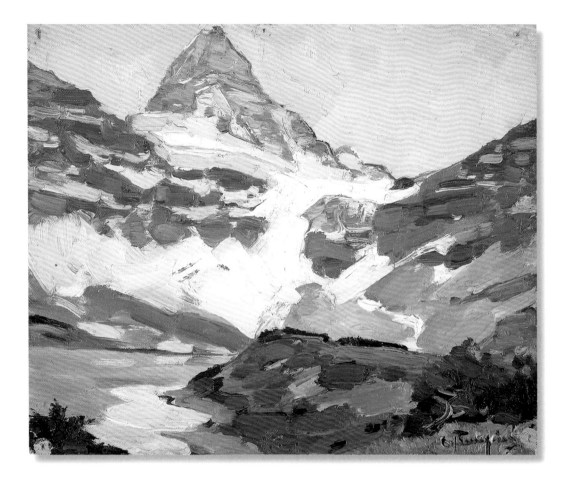

Barbara Leighton

Lunette Peak, n.d.

WOODCUT ON PAPER (25/100), 33.5 × 40.0 CM
COLLECTION OF THE WHYTE MUSEUM OF THE CANADIAN ROCKIES

Barbara Leighton, an accomplished artist and founder of the Leighton Foundation in Millarville, Alberta, often painted with her husband, A.C. Leighton, on his pack trips into the wilderness solitude. In this image, she depicts a scene seldom observed, let alone painted. Most visitors to Mount Assiniboine see the classic pyramid from the north, with Lunette just behind to the left, but Leighton appears to be looking at the cloud-shrouded spire of Lunette from the southwest, possibly on a ledge above Assiniboine Creek near Lunette Lake. A lower mountain, possibly around 8000 feet, dominates the middle ground, and Terrapin Mountain appears to be in the right background, with the shoulder of Mount Gloria at right centre. Outram's initial attempt to climb Assiniboine in poor visibility resulted in the first ascent of Lunette; for him, as in this scene, the peak of Assiniboine, just beyond Lunette, was obscured by cloud. Despite snow lying on the ground and in distant gullies, Leighton gives her scene warmth through the reddish tones of the rock repeated in the foreground, in the oddly shaped summit in the middle ground, and in the distant mountains on the right. From the early summer green of the meadow, we look across two cloud-filled ravines and up from the tips of the evergreens to the twin peaks of the near mountain and, finally, to the summit of Lunette. Leighton portrays a remote landscape, still and precipitous, its rugged beauty softened by the alpine meadow.

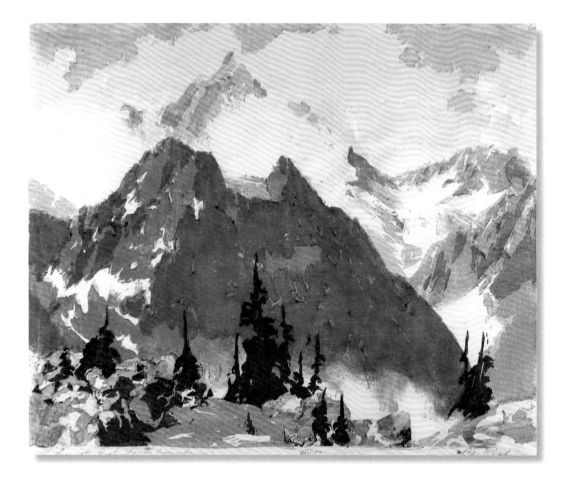

A.C. LEIGHTON

Mt. Assiniboine, n.d.

PASTEL, 42.5 × 52.0 CM
COLLECTION OF THE WHYTE MUSEUM OF THE CANADIAN ROCKIES

This sketch on brown paper was done from the shore of Lake Magog. Leighton is look-ing up to the towering summit; his paper barely contains the distance from the lake to the peak. Clouds appear to be swirling around the mountaintop as Assiniboine cre-ates its own weather. Leighton's use of colour unifies the image with the white snow throughout, the blue of the glacier repeated in the lake, and the darker hues of the rocky ledges revealed also in the foreground. The softer lines of the snow in the gullies and on the glacier flowing over the cliff in the middle of the painting are in contrast to the sharp ridges of Assiniboine. The sketch has a spontaneity, capturing the remote beauty of this challenging, magnificent peak.

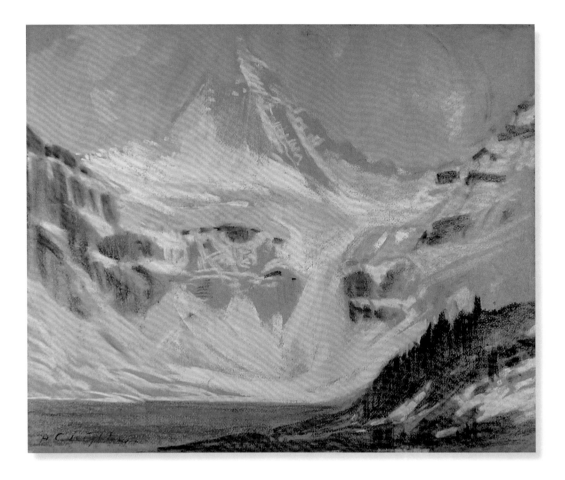

PETER WHYTE

Mount Assiniboine, September Snow, n.d.

OIL ON CANVAS, 64.0 × 74.0 CM
COLLECTION OF THE WHYTE MUSEUM OF THE CANADIAN ROCKIES

Peter Whyte's image of Assiniboine in fresh snow is a finished painting, probably done from a sketch during his stay at the lodge in September 1937. Catharine's long letter to her mother on the 22nd describes a heavy snowfall after five days of almost perfect warm weather. Peter felt that the snow provided the best day for sketching; the previous winter in Banff had not produced a snowfall of even half this magnitude. His exhilaration is evident in this scene, brilliant in the morning light. The viewer's eye follows the snowy path between the trees in front of the lodge toward the summit of Assiniboine, with clouds typically piling up against its eastern face as the sun rises. The painting conveys a great sense of morning stillness and peace in the clearing after the storm. There is no wind to blow away the snow bowing the branches. In contrast to the tones of blue and white, the golden needles of the larches lend a touch of warmth. Peter has captured a moment of incredible beauty, truly a winter landscape at Assiniboine.

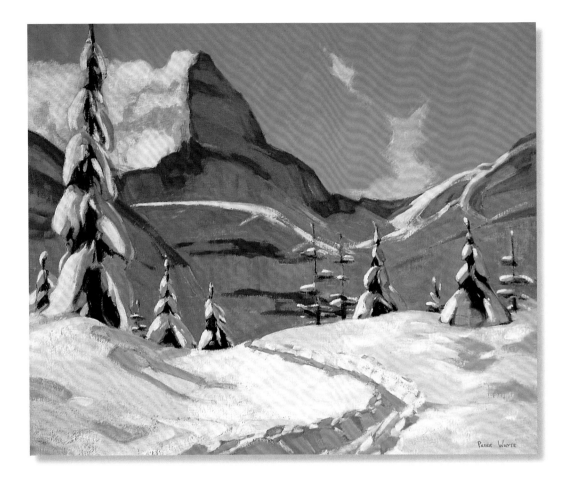

CATHARINE WHYTE

Mount Assiniboine, n.d.

OIL ON CANVAS, 22.8 × 27.8 CM
COLLECTION OF THE WHYTE MUSEUM OF THE CANADIAN ROCKIES

Catharine Whyte's sketch appears to have been painted from the Nublet, looking past the shoulder of Wedgwood Peak and up to the glacier and the soaring peak of Assiniboine. In a letter to her mother (September 1937), Catharine describes an afternoon sketching trip with Peter to a ridge overlooking two lakes, probably Sunburst and Cerulean, while they still enjoyed warm fall weather. The afternoon sun in Catharine's painting shines on the glacier and the west face of Assiniboine. She uses a limited palette, with tones of brown, blue, and white, but the contrast in value gives the image great vitality. The light on the glacier repeats the shape of the ephemeral band of cloud stretching the width of the canvas behind Mount Assiniboine. Catharine's great expanse of sky places the free-flowing clouds behind the formidable strength of the mountain.

PETER WHYTE

Alpine Club Cabin, n.d.

OIL ON CANVAS, 27.6 × 35.0 CM
COLLECTION OF THE WHYTE MUSEUM OF THE CANADIAN ROCKIES

Peter's sketch shows one of the Naiset Huts, originally built as Wonder Lodge by A.O. Wheeler to provide accommodation for his walking tours in the early 1920s. These huts were located on land owned by the Alpine Club of Canada in a treed area near the northeast end of Lake Magog. Only the log wall of the cabin is visible under the snow-laden roof. The evergreens have all but disappeared, becoming tall, snowy shapes. Catharine, in a letter to her mother (September 22, 1937), remarks on the amount of snow that fell so quickly. Peter's quick brush strokes have delineated the trees standing straight, surrounding the horizontal roof, and the spontaneous interplay of sunlight and shadow is wonderful. His image shows that the mounds of snow in all their freshness and beauty have almost covered man's habitation.

CATHARINE WHYTE

Strom's Cabin, Mount Assiniboine, 1937

OIL ON CANVAS, 22.5 × 27.8 CM
COLLECTION OF THE WHYTE MUSEUM OF THE CANADIAN ROCKIES

The position of this cabin in an open meadow with trees framing the view from the front window suggests it is one of the original six cabins built with the lodge in 1928, possibly, according to Sepp Renner, the present Magog cabin. The forest beyond the seven evergreens weighed down with snow can be discerned through the low cloud, but the mountains are obscured. The undulating snow cover and gracefully bowing trees contrast with the straight lines of the cabin. Catharine notes in her letter to her mother on September 22, 1937 how pretty the larch needles look under the snow. In this sketch, she places a single, small larch in the foreground surrounded by an expanse of white. The warmth of the yellow needles lead the eye to the brown tones in the log cabin and the woodpile, colours that lend a sense of comfort in the midst of the cold, snowy landscape.

W. J. Bradley

Mount Assiniboine in September, 2000

WATERCOLOUR ON PAPER, 27.9 × 35.6 CM
PRIVATE COLLECTION OF W.J. BRADLEY

Of all the places I have been, none have affected me in quite the same way as Assiniboine. I was born in Banff and have spent most of my life in the mountains but I was not prepared for how deeply Mt. Assiniboine moved me. And then, with the exquisite lakes surrounding it, I became so awestruck that my inspiration for the area has not diminished. The variance in the colours of the waters—the rock faces in different lights—the terrain that moves from rock to lush underbrush and moss—and the sacred sentries of larches … there is nowhere else like it on earth, I'm sure. But the larches in fall! Now that is indescribable in words. Painting them doesn't do them justice either! They need to be felt and smelt and breathed in to be appreciated.—W.J. BRADLEY, JANUARY 5, 2007

W.J. Bradley has a special fondness for the Mount Assiniboine area because her grandfather Chuck Millar worked for many years as Erling Strom's packer, while her grandmother helped Lizzie Rummel at Sunburst. In this watercolour, a studio piece painted from a *plein air* sketch made during a visit in 1997, W.J. Bradley captures the momentary beauty of sunrise. The first rays of sunshine bring colour to the peaks and to the fall foliage in the meadow near the lodge cabins. Assiniboine's pyramid rises gloriously into a blue sky, flanked by the glowing summits of Mount Magog on the left and Wedgwood Peak on the right, while, below, the grey rock faces interlaced with snow suggest the coolness of a fall morning. The eye travels from the foreground down the gully between the log cabins to Lake Magog and then up to Assiniboine. This painting has a freshness and spontaneity, a wonderful recreation of Assiniboine in the morning light.

JIMMY SIMPSON

Untitled (Mount Assiniboine), 1945

WATERCOLOUR, 32.0 × 24.0 CM
COLLECTION OF NUM-TI-JAH LODGE

Jimmy Simpson first travelled to Mount Assiniboine in 1900 as the cook in an outfit supplied by Tom Wilson for the ill-fated expedition of the Walling brothers. Forty-five years later, Simpson painted this watercolour of the mountain, possibly from a photograph. In the intervening years, artists such as Belmore Browne and Carl Rungius had become his friends, and he learned by watching them at work. His perspective on Assiniboine is from the end of Lake Magog, looking up to the west face of the mountain, over the shoulder of Wedgwood Peak. The triangular summit seems to glow in the afternoon sun, and the threatening clouds piled behind are tinged with the same colours found in the meadow in the foreground. Simpson's use of light and colour lend a warmth to the striking peak rising from the glacier.

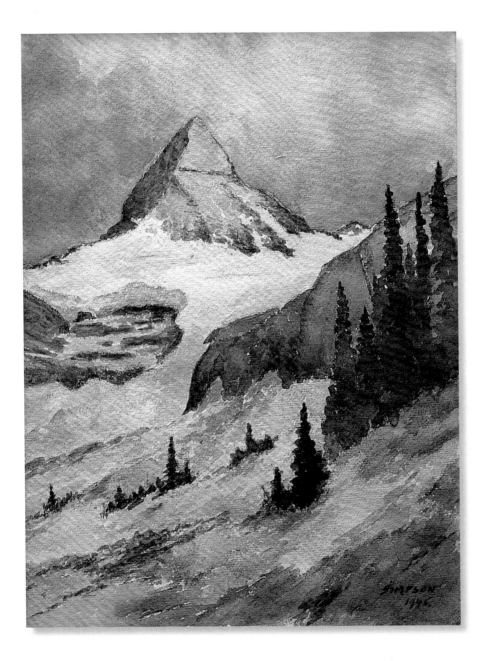

Jimmy Simpson

Untitled (Moonlight on Mount Assiniboine), 1941

WATERCOLOUR, 30.4 × 22.8 CM
COLLECTION OF THE WHYTE MUSEUM OF THE CANADIAN ROCKIES

Under his signature and the date, Jimmy Simpson has pencilled a greeting to "Jim Parrish with regards." This watercolour was presumably sent as a gift; many of his small sketches have inscriptions to friends. The perspective is similar to his image of Assiniboine in the afternoon sun, but here the landscape is snow covered and bathed in the light of the full moon. Our eye is drawn from the clump of trees up the snow chute to the glacier, then to the peak of Assiniboine, and finally to the celestial body, the moon, higher than the mountain, and the focus of Simpson's watercolour. This nocturnal view of Assiniboine is magical, both romantic and haunting.

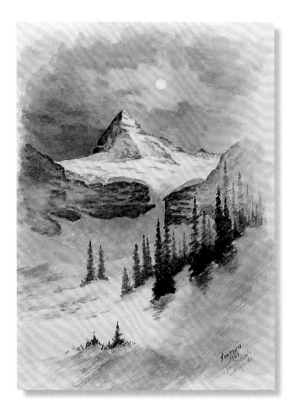

GLEN BOLES

Mount Assiniboine, 1995

PEN AND PENCIL ON WATERCOLOUR PAPER (183/275), 37.5 × 49.5 CM
PRIVATE COLLECTION OF GLEN BOLES

As a member of the legendary Grizzly Group, Glen Boles brings an extensive knowledge of mountaineering to his images of the alpine landscape. His portrait of Assiniboine draws the eye from Lake Magog up an astonishing 1475 metres to the peak set against horizontal bands of cloud. He includes such incredible detail that a potential climber of the mountain could anticipate some of the hazards in the ascent, including the bergschrund at the base of Assiniboine's pyramid. Using just pen and pencil to indicate the contrast between light and dark, Glen creates tonal variations that are truly wonderful: the delicate shadows on the snow and the softness of clouds and the lake's reflections are juxtaposed with the solidity and strength of the darker rock. This image portrays Assiniboine in all of its power and awesome beauty, giving us the climber's love of the natural grandeur and respect for the challenge of the ascent.

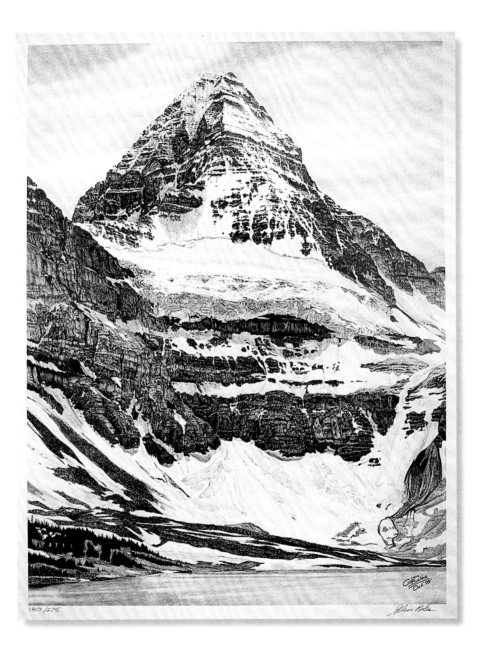

GLEN BOLES

Mount Assiniboine, 2007

ACRYLIC ON CANVAS, 61.0 × 91.4 CM
PRIVATE COLLECTION OF SHARON AND ALAN COLE

Glen Boles captures the majestic presence of Mount Assiniboine. One can imagine actually pausing beside the trail to Sunburst Lake, looking across the sunlit meadow, and following the mountain's tremendous vertical rise to the summit against the blue sky. A drifting cloud almost seems to touch the very top of Assiniboine. In the distance, the peak of Mount Sturdee appears on the horizon. The shadowed headwall of Assiniboine in the middle of the painting emphasizes the brilliance of the glacier while, above, the western ridges and the triangular peak with their dusting of snow are illuminated by sunshine. With his sensitivity to light and his amazing detail, Glen Boles creates an inspiring image of this great mountain.

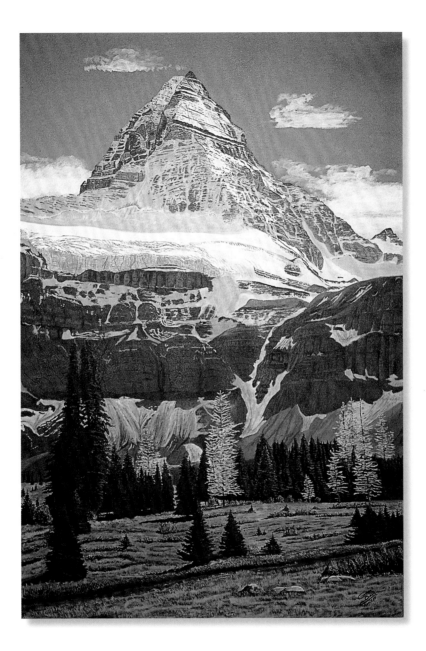

JOE PLASKETT

Mount Assiniboine, 1972

PASTEL ON PAPER, 62.4 × 47.2 CM
COLLECTION OF GLENBOW MUSEUM

Even though Joe Plaskett pursued his artistic career in Paris, he did not forget the mountains he had seen while staying at Sunburst Camp in the early 1950s. His quick sketch of Assiniboine from Lake Magog to the peak in the clouds is powerful and dramatic. The patches of blue sky suggest a summer's day, but, characteristically, the mountain appears to be creating its own weather. The swirling mist threatens to obscure the sharp, vertical lines of the summit. The contrast of black rock against snow and cloud is enlivened by the icy edge of the glacier, a colour repeated in the bluish green lake below. With energetic strokes, Plaskett celebrates the rugged beauty of this formidable mountain.

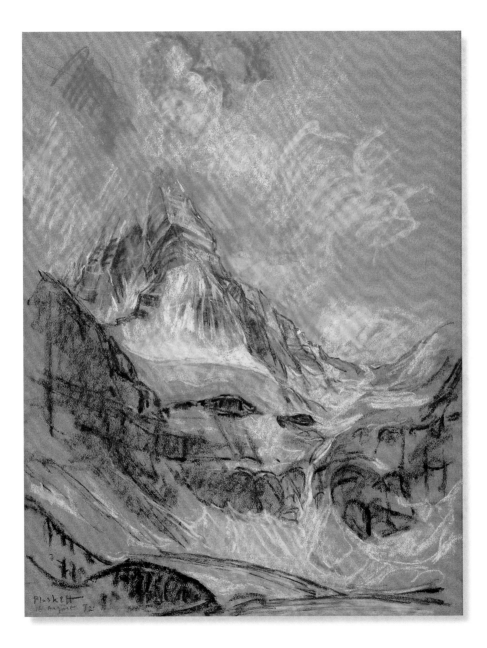

HOLLY MIDDLETON

Mount Assiniboine, 1976

WATERCOLOUR ON PAPER, 42.2 × 58.1 CM
COLLECTION OF THE WHYTE MUSEUM OF THE CANADIAN ROCKIES

Holly Middleton's vantage point on the shore of Lake Magog is a favourite one for artists and photographers. The landscape has symmetry, with Mount Magog and Wedgwood Peak framing Assiniboine and the lower Mount Strom behind. Middleton has chosen to paint in the late spring, with snow on the ground and the lake still partially frozen. Her delicate washes and transparent colours give a sense of thawing, a landscape anticipating the warmth of the sun and renewed growth. Storm clouds appear to be gathering around Assiniboine's summit, but, for the moment, the watery reflections suggest a stillness in the midst of awesome alpine beauty.

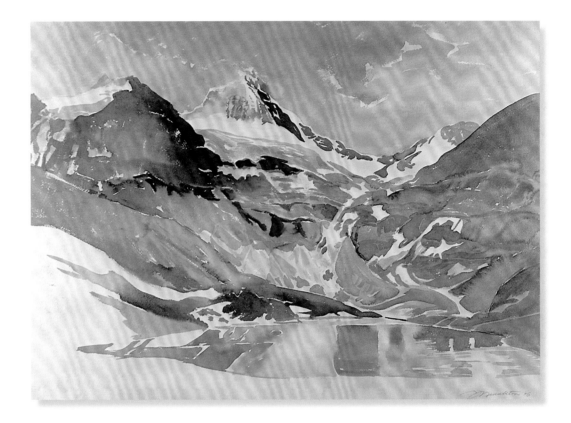

DONNA JO MASSIE

Mount Assiniboine, 1998

WATERCOLOUR ON PAPER, 53.3 × 43.2 CM
PRIVATE COLLECTION OF DONNA SCHLEY AND PAUL PRICE

The golden larches epitomize the fall in the high alpine landscape. Donna Jo Massie places them at the centre of her painting; the trees catch the morning sunshine and cast long shadows over patches of snow. The vibrant larches, with their graceful branches, point toward the powerful, dominant peak of Assiniboine in the distance. This water-colour seems to convey a crispness and coolness in the morning air. The intense colour of the larches will soon give way to winter snow, their brilliance nature's exuberance before the season changes. Donna Jo captures this mutable beauty in an enduring land-scape of majestic peaks.

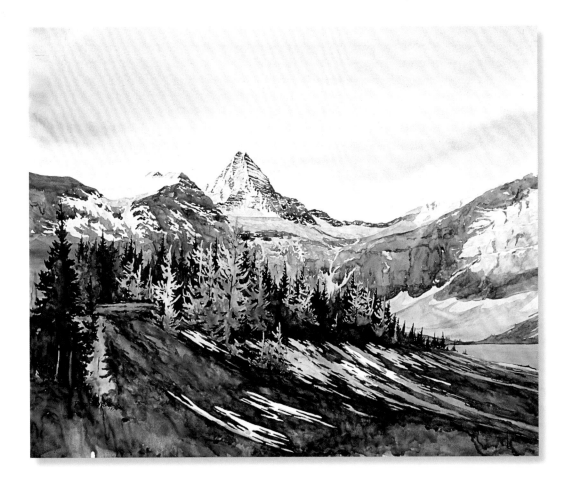

JEAN PILCH

The Reflecting Pond, 2005

ACRYLIC ON CANVAS, 30.5 × 40.6 CM
PRIVATE COLLECTION

Jean Pilch presents a rare, magical moment of stillness and beauty just before the sun goes down. The west faces of Mounts Magog and Assiniboine, warmed in the last rays of sunshine, are precisely reflected in the perfectly smooth pond near the lodge. The clarity of detail is wonderful. The watery image appears to be an exact reflection until one notices the artist's great sensitivity to light and value. The darkest tones are in the middle of the painting, providing a contrast and balance between the lighter peaks above and the image below. The reflection in the pool, however, is closest to the viewer, and the colours are deepened; the sky is a darker blue, and the peak of Assiniboine reveals two strongly contrasted faces, one glowing reddish brown in the setting sun, the other a deep blue in the shadows, but both coming to a dramatic point in the foreground. Jean Pilch captures this wondrous double image of Assiniboine just before the light fades.

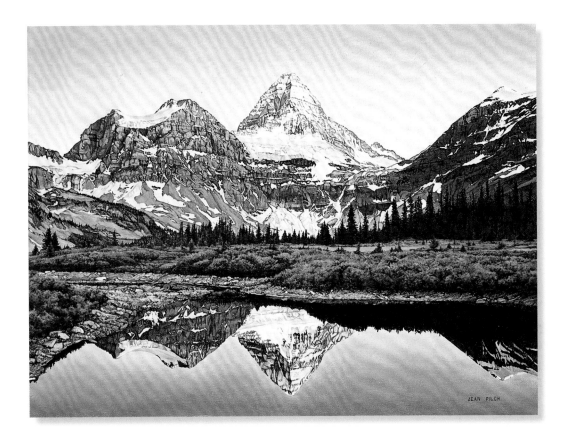

ALICE SALTIEL-MARSHALL

Mount Assiniboine, Stormy Sky, 1992

STUDIO OIL, 25.4 × 20.3 CM
PRIVATE COLLECTION

Alice portrays a fleeting moment when the peak of Assiniboine, covered with fresh snow and catching the first rays of sunshine, stands out against the deep shadows below and the storm clouds behind. The summit from this perspective, near the base at the end of Lake Magog, is always awe-inspiring, but the effect of light in the painting brings Assiniboine into even greater prominence. The mountain is so high that clouds frequently form near the top; here they threaten to eclipse the spectacular peak, possibly bringing more snow. This image is filled with nature's energy on a grand scale.

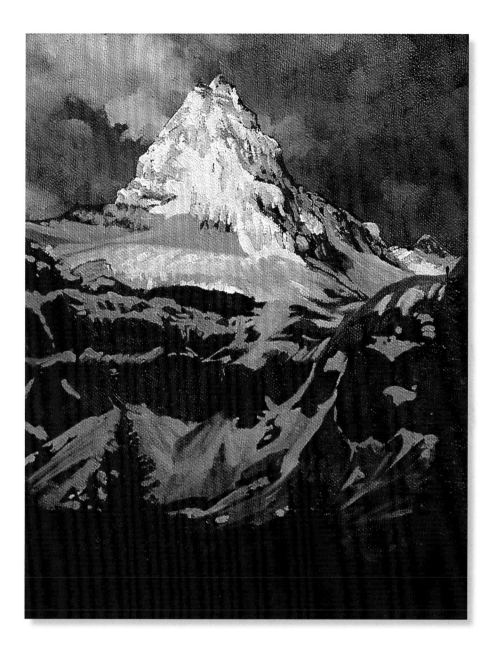

ALICE SALTIEL-MARSHALL

Zelda Dawn, Mount Assiniboine, 1994

STUDIO OIL, 45.7 × 61.0 CM
PRIVATE COLLECTION OF HANS JINTES

This inspiring image of the rising sun illuminating the summits is named after Zelda Nelson, a friend and fellow artist from Canmore, Alberta. Alice captures the precious moments of dawn at Mount Assiniboine. The mist over the lake is starting to rise and dissipate as the sun brings colour and warmth to the alpine scene. The painting presents a striking contrast between the shadows at lower elevations and the sparkling snow against the reddish brown rock of the sunlit peaks. The fog bank creates an emphatic white band across the middle, soon to disappear. The amazing quality of this painting is the portrayal of the transformation of the landscape through sunlight. The fog will magically dissolve and the dark world below will soon be filled with sunshine, but, for now, the peak of Mount Assiniboine is set apart, brilliant against the morning sky.

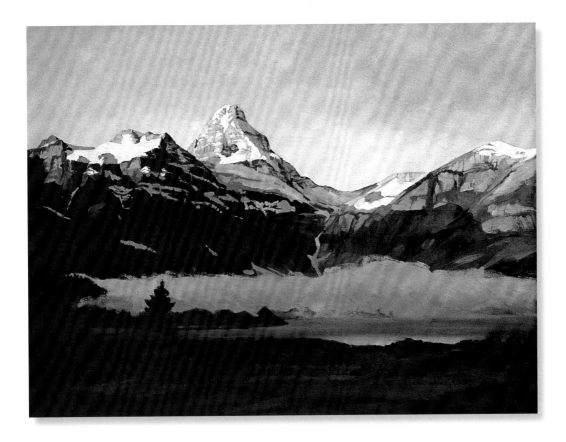

ZELDA NELSON

Mount Assiniboine, *2004*

OIL ON CANVAS, 81.3 × 116.8 CM

PRIVATE COLLECTION OF CATHERINE GOULET AND MICHAEL HARRIS

Zelda Nelson portrays an image of Mount Assiniboine in the tranquility and beauty of a summer morning. The sunshine brings out the fresh, crisp colours in the illuminated rock and meadow, while the western faces of Mounts Magog and Assiniboine, together with the headwall below the glacier, are still in shadow. Mount Assiniboine rises above this interplay of light and dark into a sky of rolling clouds to the south. Zelda describes the striking backdrop to Assiniboine as the result of the "morning sun breaking away the clouds that blanketed the night sky."

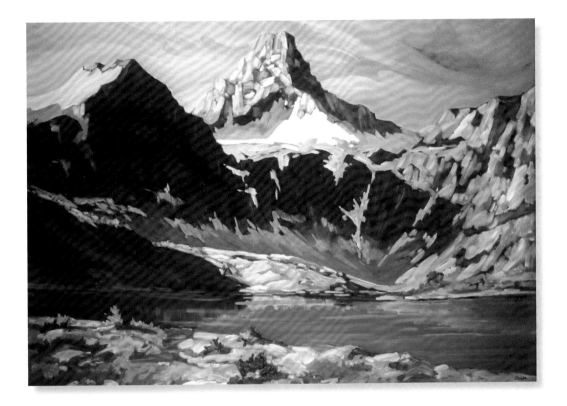

Zelda Nelson

The Headwall at Mount Assiniboine, 2006

OIL ON CANVAS, 71.1 × 142.2 CM
PRIVATE COLLECTION OF ALAN AND DIANE STOKES

Instead of presenting Assiniboine's peak, Zelda focuses on the magnificent headwall supporting the glacier and the triangular summit above. Climbers must ascend this wall to reach the R.C. Hind alpine hut or to make an attempt on the peak. Zelda's vantage point is at the end of Lake Magog, where the vegetation ends. The vertical dimensions of the painting lead the eye from the flaming larches up to tongues of ice on the wall and the massive glacier, with Assiniboine's summit just suggested as it soars beyond the frame. The interplay of diagonal lines divides the painting into three, with the darker headwall between the ice above and the fiery trees below, unified through the illumination by the morning sunlight. Assiniboine's rock and ice are images of enduring strength in contrast with the brilliant colour of the ephemeral autumn foliage.

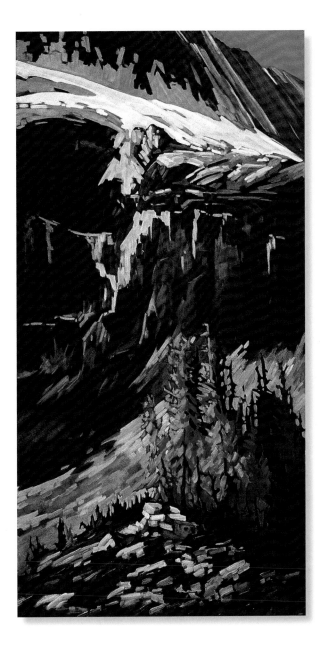

SIMON CAMPING

Apparition II, 2005

ACRYLIC ON WATERCOLOUR PAPER, 55.6 × 75.9 CM
PRIVATE COLLECTION

Simon Camping has visited the Assiniboine area at least 20 times, taking photographs and working from them later in his studio. His perspective on Assiniboine, framed by Mount Magog and Wedgwood Peak, is not unusual, but the clarity and detail in his painting are wonderful. The still reflection in Lake Magog, the second image or apparition, is an amazing, watery reproduction of the landscape above. His sensitivity to the dynamic interaction of light and shadow is evident in the line that gently undulates down the middle of the painting. Mount Assiniboine rises above, its peak radiant in the morning sunshine. Camping takes a moment of incredible beauty out of the flow of time, holding it for us to see before the light shifts and the ripples disturb the reflection.

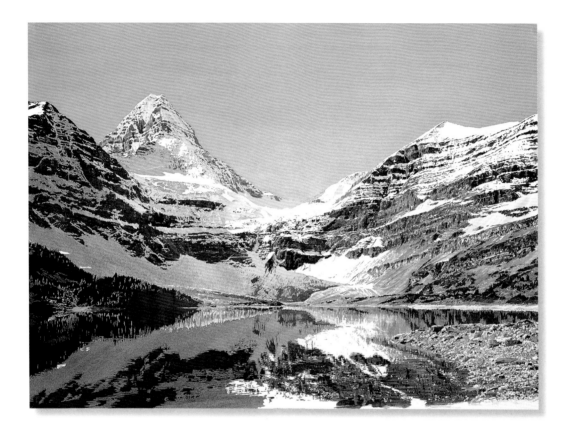

Endnotes

1 Walter D. Wilcox, *Camping in the Canadian Rockies*, 2nd ed. (New York and London: G.P. Putnam's Sons, The Knickerbocker Press, 1897), 153.

2 Lillian Gest, *History of Mount Assiniboine in the Canadian Rockies* (NP: np, 1979), 10.

3 Barbara Renner, *Mount Assiniboine Lodge Cook Book* (Banff and Calgary: Unicom Graphics Ltd., 1993), [6].

4 *The Rockies of Canada*, a revised and enlarged edition of *Camping in the Canadian Rockies*, 3rd ed. (New York and London: G.P. Putnam's Sons, The Knickerbocker Press, 1909), 69.

5 Gest, *History*, 11.

6 E.J. Hart, *Diamond Hitch* [:] *The Pioneer Guides and Outfitters of Banff and Jasper* (Banff: EJH Literary Enterprises Ltd., 2001), 33. (Originally published in 1979 by Summerthought Ltd.)

7 Hart, *Diamond*, 33.

8 Hart, *Diamond*, 33.

9 Hart, *Diamond*, 34.

10 Hart, *Diamond*, 35.

11 Hart, *Diamond*, 45.

12 "Mountaineering in the Canadian Rockies," *The Alpine Journal*, XVIII, 134 (November 1896), 222–236.

13 Allen, "Mountaineering," 232.

14 Allen, "Mountaineering," 232.

15 Allen, "Mountaineering," 233.

16 Allen, "Mountaineering," 233.

17 Allen, "Mountaineering," 233.

18 Allen, "Mountaineering," 234.

19 E.J. Hart, ed., *Ain't it Hell* [:] *Bill Peyto's "Mountain Journal"* (Banff: EJH Literary Enterprises, 1995), 12.

20 Wilcox, *Rockies*, 77.

21 Don Beers (*Banff-Assiniboine: A Beautiful World* (Calgary: Highline Publishing, 1993, 66) notes that in 1941 Bettie Cowie

caught 54 fish in Rock Lake in about an hour and a half.

22 Wilcox, *Rockies*, 81.

23 Erling Strom, "Mount Assiniboine History," *The Assiniboine Wrangler*, 6 (December 1955), 2, 4. In Strom Papers (Banff: Archives of the Whyte Museum of the Canadian Rockies), M110.4.

24 Wilcox, *Rockies*, 89.

25 Wilcox, *Rockies*, 89.

26 Wilcox, *Rockies*, 93.

27 Hart, *Ain't it Hell*, 16.

28 Hart, *Diamond*, 46.

29 Hart, *Diamond*, 46.

30 Hart, *Ain't it Hell*, 15.

31 Hart, *Diamond*, 47.

32 Wilcox, *Rockies*, 100.

33 Wilcox, *Rockies*, 99.

34 Wilcox, *Rockies*, 106.

35 Wilcox, *Rockies*, 106.

36 Wilcox, *Rockies*, 110.

37 James Simpson, "Days Remembered," *American Alpine Journal*, XIX, 1 (1974), 46.

38 Simpson, "Days Remembered," 46.

39 Simpson, "Days Remembered," 46.

40 Simpson, "Days Remembered," 46.

41 E.J. Hart, *The Selling of Canada* [:] *The CPR and the Beginnings of Canadian Tourism* (Banff: Altitude Publishing Ltd., 1983), 67.

42 Brian Brennan, *Romancing the Rockies: Mountaineers, Missionaries, Marilyn, and More* (Calgary: Fifth House Ltd., 2005), 55.

43 Hart, *Ain't it Hell*, 89–93.

44 Hart, *Ain't it Hell*, 92–93.

45 Hart, *Ain't it Hell*, 97–98.

46 Hart, *Ain't it Hell*, 99.

47 Walter D. Wilcox, "An Early Attempt to Climb Mt. Assiniboine," *Canadian Alpine Journal*, II (1909–10), 23–24.

48 Hart, *Ain't it Hell*, 101.

49 James Outram, "Mount Assiniboine," *In the Heart of the Canadian Rockies* (London and New York: The Macmillan Company,

1923), 38–71. (First published in 1905.) *See also* note 52ff.

50 Hart, *Ain't it Hell*, 104.

51 Hart, *Ain't it Hell*, 105.

52 James Outram, "The First Ascent of Mt. Assiniboine," *The Alpine Journal*, XXI, 156 (May 1902), 107–108.

53 Outram, "First Ascent," 108.

54 Outram, "First Ascent," 110–111.

55 Outram, "First Ascent," 114.

56 Outram, "First Ascent," 114.

57 Gest, *History*, 20.

58 Brennan, *Romancing*, 91.

59 "The Ascent of Mt. Assiniboine," *Canadian Alpine Journal*, I, 1 (1907), 90–94.

60 E.J. Hart, *Jimmy Simpson* [:] *Legend of the Rockies* (Canadian Rockies/Vancouver: Altitude Publishing, 1991), 39.

61 Hart, *Diamond*, 150.

62 Mary Vaux Walcott, "Forward," *North American Wild Flowers*, vol. 1 (Washington, D.C.: Smithsonian Institution, 1925), [v].

63 Cyndi Smith, *Off the Beaten Track* [:] *Women Adventurers and Mountaineers in Western Canada* (Canmore: Coyote Books, 1989), 47.

64 Hart, *Ain't it Hell*, 128.

65 Wilcox, *Rockies*, 119.

66 Hart, *Simpson*, 47.

67 Hart, *Simpson*, 48.

68 Hart, *Simpson*, 48–49.

69 Phil Dowling, *The Mountaineers* [:] *Famous Climbers in Canada* (Edmonton: Hurtig Publishers, 1979), 107.

70 Dowling, *Mountaineers*, 111–112.

71 Renner, *Cook Book*, [24].

72 Christine Barnes, *Great Lodges of the Canadian Rockies* (Bend, Oregon: W.W. West, 1999), 140.

73 Gest, *History*, 23–24.

74 Gest, *History*, 22.

75 F.O. 'Pat' Brewster, *Weathered Wood* [:] *Anecdotes and History of the Banff-Sunshine Area* (Banff: Crag and Canyon, 1977), 45.

76 Hart, *Diamond*, 236.

77 Hart, *Diamond*, 236.

78 "Alpine Climbing Canadian Pacific Rockies," *Resorts in the Canadian Pacific Rockies* (Canadian Pacific Railway, 1923), 13. (Calgary: Glenbow Archives), Pamphlet 75.10.15/6.

79 Barnes, *Great Lodges*, 140.

80 Hart, *Diamond*, 237.

81 Hart, *Diamond*, 238.

82 Barnes, *Great Lodges*, 140.

83 Mary Allodi, "Coleman," *Canadian Watercolours and Drawings in the Royal Ontario Museum*, vol. 1 (Toronto: Royal Ontario Museum, 1974).

84 Donald Blake Webster, "Foreward," *Canadian Watercolours and Drawings in the Royal Ontario Museum*, vol. 1 (Toronto: Royal Ontario Museum, 1974), [xi].

85 Brennan, *Romancing*, 13.

86 Brennan, *Romancing*, 17.

87 Brennan, *Romancing*, 14.

88 Brennan, *Romancing*, 18.

89 *Trail Riders of the Canadian Rockies* [:] *75th Anniversary 1923–1998* (Canmore: The Alpine Club of Canada and McAra Printing, 1998), 5–6.

90 Hart, *Diamond*, 239.

91 Terry Fenton, *A.C. Leighton and the Canadian Rockies* (Banff: Whyte Museum of the Canadian Rockies, 1989), 7.

92 John Murray Gibbon, ed., *Trail Riders Association of the Canadian Rockies Bulletin No. 29* (Montreal: Canadian Pacific Railway, 1932), 2.

93 Sandford, *Trail Riders*, 10.

94 Sandford, *Trail Riders*, 12.

95 Sandford, *Trail Riders*, 2.

96 Sandford, *Trail Riders*, 9, 11, 12, 16, 20, 22, 25.

97 Hart, *Diamond*, 240.

98 Gest, *History*, 24.

99 Erling Strom, *Pioneers on Skis* (Central Valley, New York: Smith Clove Press, 1977), 44.

100 Gest, *History*, 25.

101 Strom, *Pioneers*, 114–126.

102 Barnes, *Great Lodges*, 77, 87.

103 Barnes, *Great Lodges*, 141.

104 Renner, *Cook Book*, [2].

105 Brewster, *Weathered Wood*, 59.

106 Barnes, *Great Lodges*, 143.

107 Gest, *History*, 21.

108 "Report of the Assiniboine Camp, 1920," *Canadian Alpine Journal*, XII (1921–22), 195–196.

109 "Report of the Assiniboine Camp, 1920," *Canadian Alpine Journal*, XII (1921–22), 196.

110 "Magog Lake Camp," *Canadian Alpine Journal*, XXIII (1934–35), 118–119.

111 Smith, *Beaten Track*, 108.

112 Smith, *Beaten Track*, 110.

113 Smith, *Beaten Track*, 114.

114 Smith, *Beaten Track*, 118.

115 Gest, *History*, 34.

116 Smith, *Beaten Track*, 118.

117 Gest, *History*, 36.

118 Smith, *Beaten Track*, 208.

119 Smith, *Beaten Track*, 211–212.

120 Smith, *Beaten Track*, 212.

121 (Toronto: Ryerson Press, 1957), 47–63, 118–129.

122 Lorne E. Render, *A.C. Leighton*, Art Series No. 3 (Calgary: Glenbow-Alberta Institute, 1971), 3.

123 Fenton, *Leighton and the Canadian Rockies*, 4.

124 Fenton, *Leighton and the Canadian Rockies*, 7.

125 Fenton, *Leighton and the Canadian Rockies*, 7.

126 Leighton Papers (Banff: Archives of the Whyte Museum of the Canadian Rockies), M214, 1276.

127 Fenton, *Leighton and the Canadian Rockies*, 10.

128 Fenton, *Leighton and the Canadian Rockies*, 10.

129 Leighton Papers, M214, 1276.

130 Render, *Leighton*, 7.

131 Fenton, *Leighton and the Canadian Rockies*, 15.

132 Fenton, *Leighton and the Canadian Rockies*, 15.

133 Hart, *Simpson*, 66.

134 Hart, *Simpson*, 66.

135 Karen Wonders, "Big Game Hunting and the Birth of Wildlife Art," *Carl Rungius[:] Artist and Sportsman* (Toronto: Warwick Publishing Inc., 2001), 33.

136 Lorain Lounsberry, "Carl Rungius: Chronology," *Carl Rungius[:] Artist & Sportsman*.

137 Hart, *Simpson*, 66.

138 *See* plate 43, *Carl Rungius[:] Artist & Sportsman*, 73.

139 Wonders, "Big Game," 33.

140 *See* plate 72 and note, *Carl Rungius[:] Artist & Sportsman*, 94.

141 Lounsberry, "Chronology," 159.

142 Lounsberry, "Chronology," 158.

143 Lounsberry, "Chronology," 158.

144 Kirstin Evenden, "Introduction," *Carl Rungius[:] Artist & Sportsman*

145 Donald Harvie, "Foreward," *Carl Rungius[:] Artist & Sportsman*, 11.

146 Lorne E. Render, *The Mountains and the Sky* (Calgary: Glenbow-Alberta Institute, 1974), 171.

147 Render, *Mountains*, 171.

148 (Calgary: Glenbow Archives, 1924), Pamphlet 971.18 R68 3rst.

149 Render, *Mountains*, 171. Render also notes that Browne resided in Banff from 1921–1940.

150 Lounsberry, "Chronology," 161.

151 Jon Whyte and E.J. Hart, *Carl Rungius: Painter of the Western Wilderness* (Vancouver: Douglas & McIntyre, 1985), 117.

152 Whyte and Hart, *Rungius*, 143.

153 Render, *Mountains*, 171.

154 Lounsberry, "Chronology," 161.

155 Render, *Mountains*, 175.

156 Jon Whyte, *Mountain Glory[:] The Art of Peter and Catharine Whyte* (Banff: Whyte Museum of the Canadian Rockies, 1988), 11.

157 Whyte, *Mountain Glory*, 10.

158 Whyte, *Mountain Glory*, 10.

159 Whyte, *Mountain Glory*, 14.

160 Whyte, *Mountain Glory*, 14, note 3.

161 Whyte, *Mountain Glory*, 23–25.

162 *Fifty Years of Trails and Tales*, ed. Marian Goldstrom (Calgary: Skyline Hikers of the Canadian Rockies, 1982), 1.

163 *Fifty Years*, 14.

164 *Fifty Years*, 57, 61.

165 Catharine Whyte, Letters (Banff: Archives of the Whyte Museum of the Canadian Rockies), M36 102.

166 Ruth Oltmann, *Lizzie Rummel[:] Baroness of the Canadian Rockies* (Calgary: Rocky Mountain Books, 1983), 29.

167 Oltmann, *Baroness*, 30.

168 Oltmann, *Baroness*, 33, 35.

169 Oltmann, *Baroness*, 59.

170 Oltmann, *Baroness*, 70–71.

171 Sunburst Lake Camp Guest Book, 1953 (Banff: Archives of the Whyte Museum of the Canadian Rockies), M28 40.

172 Oltmann, *Baroness*, 141.

173 Oltmann, *Baroness*, 145.

174 Lorne Tetarenko and Kim Tetarenko. *Ken Jones[:] Mountain Man* (Calgary: Rocky Mountain Books, 1996), 173–74.

175 Tetarenko and Tetarenko, *Jones*, 178.

176 (Vancouver: Ronsdale Press Ltd., 1999), 99–101.

177 Plaskett, *Likeness*, 229.

178 Plaskett, *Likeness*, 147–148.

179 Plaskett, *Likeness*, 147.

180 Plaskett, *Likeness*, 112–113.

181 Plaskett, *Likeness*, 151–153.

182 Plaskett, *Likeness*, 232.

183 Lisa Christensen, *A Hiker's Guide to the Rocky Mountain Art of Lawren Harris* (Calgary: Fifth House Ltd., 2000), 127.

184 (Toronto: Clarke, Irwin & Co. Ltd., 1964), 37.

185 Jackson, *A Painter's Country*, 37.

186 "Artists in the Mountains," *The Canadian Forum*, V, 52 (January 1925), 114.

187 Naomi Jackson Groves, *A.Y.'s Canada* (Toronto: Clarke, Irwin & Co. Ltd., 1968), 150.

188 "Artists in the Mountains," 114.

189 Groves, *A.Y.'s Canada*, 144.

190 Groves, *A.Y.'s Canada*, 150.

191 Douglas Cole and Maria Tippett, eds., *Phillips in Print[:] The Selected Writings of Walter J. Phillips on Canadian Nature and Art*, vol. 6 of The Manitoba Record Society Publications (Winnipeg: The Manitoba Record Society, 1982), xix.

192 Cole and Tippett, *Phillips in Print*, xi.

193 Duncan Campbell Scott, *Walter J. Phillips* (Toronto: The Ryerson Press, 1947), 28.

194 Cole and Tippett, *Phillips in Print*, xxi.

195 Scott, *Phillips*, 32.

196 Cole and Tippett, *Phillips in Print*, 104.

197 G.H.W. 'Herb' Ashley, Letter to W.P. Morgan, Curator, Dunlop Art Gallery, June 15, 1981. Copy courtesy of Glenbow Archives.

198 Les Graff, "Middleton," Exhibition Notes and Biography (Edmonton, n.d.).

199 Graff, "Middleton."

200 Graff, "Middleton."

201 R.W. Sandford, *Once Upon a Mountain[:] The Legend of the Grizzly Group* (Canmore: The Alpine Club of Canada and McAra Printing, 2002), 4, 6.

202 Sandford, *Once Upon a Mountain*, 23.

203 Conversation with W.J. Bradley in Banff, August 1, 2006.

204 "Zelda Faye Nelson," *International Artist*, 37 (June/July 2004), 117.

List of Artists

GEORGE HERBERT WILLIAM (HERB) ASHLEY (1908–2004)
Marvel Lake, 1949
Oil on canvas 53.5 × 63.5 cm
Collection of Glenbow Museum,
Calgary, Canada
R780.2, Photograph no. P0006382

GLEN W. BOLES (1935–)
Mount Assiniboine, 1995
Pen and pencil on watercolour paper
37.5 × 49.5 cm
Private collection of Glen Boles
Photograph: Glen Boles

Mount Assiniboine, 2007
Acrylic on canvas 61.0 × 91.4 cm
Private collection of
Sharon and Alan Cole
Photograph: Glen Boles

W.J. BRADLEY (1958–)
Mount Assiniboine in September, 2000
Watercolour on paper 27.9 × 35.6 cm
Private collection of W.J. Bradley
Photograph: Roy Andersen

BELMORE BROWNE (1880–1954)
Mountain Goats and Mt. Assiniboine, 1947
Oil on canvas 45.0 × 59.0 cm
Collection of the Whyte Museum of
the Canadian Rockies. BWB.02.06

Rainy Day at Marvel Lake, 1934
Oil on canvas 30.5 × 40.6 cm
Collection of Glenbow Museum, Calgary,
Canada 55.48.15, Photograph no. 631

SIMON CAMPING (1928–)
Apparition II, 2005
Acrylic on watercolour paper
55.6 × 75.9 cm
Private collection

Winter, Sunburst Peak, 2005
Acrylic on watercolour paper
75.9 × 55.3 cm
Private collection

ARTHUR PHILEMON COLEMAN (1852–1939)
Mount Assiniboine, Morning, 1920
Watercolour over pencil 17.4 × 12.7 cm
With permission of the Royal Ontario
Museum © ROM. 932.39.87

Tepee, Assiniboine Camp, 1920
Watercolour over pencil, 17.4 × 12.7 cm
With permission of the Royal Ontario
Museum © ROM. 932.39.86

*Tower Mountain near Assiniboine,
Evening*, 1920
Watercolour over pencil, 12.7 × 17.4 cm
With permission of the Royal Ontario
Museum © ROM. 932.39.88

*Tower Mountain near Assiniboine,
Morning*, 1920
Watercolour over pencil, 12.7 × 17.4 cm
With permission of the Royal Ontario
Museum © ROM. 932.39.89

JEAN GEDDES (1937–)
Aurora's Mirror, near Mount Assiniboine,
2006
Oil on linen, 76.2 × 76.2 cm
Private collection of the artist

ALEXANDER YOUNG (A.Y.) JACKSON (1882–1974)
Mount Assiniboine, Banff, 1943
Graphite on wove paper 22.7 × 30.0 cm
Collection of the National Gallery of
Canada, Ottawa
Gift of the artist, Kleinburg, Ontario,
1974
Courtesy of the Estate of the late
Dr. Naomi Jackson Groves, 17835R

ALFRED CROCKER (A.C.) LEIGHTON (1900–1965)
Mt. Assiniboine, no date
Pastel 42.5 × 52.0 cm
Collection of The Whyte Museum of
the Canadian Rockies. LaC.03.13

Mount Assiniboine, no date
Oil on linen 66.3 × 76.6 cm
Art Gallery of Alberta Collection
Purchased in 1989 with funds from the

Art Associates of the Edmonton Art
Gallery
Photograph © Art Gallery of Alberta
89.19

BARBARA MARY (HARVEY) LEIGHTON (1911–1986)
Lunette Peak, no date
Woodcut on paper (25/100)
33.5 × 40.0 cm
Collection of The Whyte Museum of
the Canadian Rockies. LeB.04.06

The Towers, Mt. Assiniboine, no date
Woodcut on paper (32/100)
31.5 × 37.0 cm
Collection of The Whyte Museum of
the Canadian Rockies. LeB.04.16

DONNA JO MASSIE (1948–)
Mount Assiniboine, 1998
Watercolour on paper 53.3 × 43.2 cm
Private collection of Donna Schley and
Paul Price. Photograph: Bill Marshall

Trail to The Towers, 2001
Watercolour on paper 35.6 × 71.1 cm
Private collection

JANET HOLLY B. MIDDLETON (1922–)
Mount Assiniboine, 1976
Watercolour on paper 42.2 × 58.1 cm
Collection of The Whyte Museum of
the Canadian Rockies. MiJ.05.02

ZELDA NELSON (1943–)
The Headwall at Mount Assiniboine, 2006
Oil on canvas 71.1 × 142.2 cm
Private collection of Alan and
Diane Stokes
Photograph: Roy Andersen

Mount Assiniboine, 2004
Oil on canvas 81.3 × 116.8 cm
Private collection of Catherine Goulet
and Michael Harris

FRANK SHIRLEY PANABAKER (1904–1992)
Mount Assiniboine (The Towers), c. 1925
Oil on canvas 26.5 × 34.0 cm
Collection of The Whyte Museum of
the Canadian Rockies. PaF. 02.01

WALTER JOSEPH PHILLIPS (1884-1963)
Assiniboine, 1946
Watercolour on paper 30.5 × 23.0 cm
Collection of Glenbow Museum,
Calgary, Canada
62.21.31.009, Photograph no. P0006383

Mount Assiniboine from Sunshine Meadows,
1945
Watercolour on paper 28.7 × 37.8 cm
Collection of The Whyte Museum of
the Canadian Rockies. Phw.05.14

JEAN PILCH (1947-)
Jewels at My Feet, 2005
Pastel on paper 29.2 × 40.6 cm
Private collection
Photograph: Peter Pilch

The Reflecting Pond, 2005
Acrylic on canvas 30.5 × 40.6 cm
Private collection
Photograph: John Dean

JOSEPH PLASKETT (1918-)
Mount Assiniboine, 1972
Pastel on paper 62.4 × 47.2 cm
Collection of Glenbow Museum,
Calgary, Canada
986.57.1, Photograph no. 15261

CARL CLEMENS MORITZ RUNGIUS (1869-1959)
Mount Assiniboine, no date
Oil on canvas 22.9 × 27.9 cm
Collection of Glenbow Museum,
Calgary, Canada
55.12.23, Photograph no. 2984

Mt. Assiniboine and Lake Magog, no date
Oil on canvas 22.6 × 27.9 cm
Collection of Glenbow Museum,
Calgary, Canada
59.7.1253, Photograph no. 2540

ALICE SALTIEL-MARSHALL (1948-)
Elizabeth Lake, 2007
Oil on board, 30.5 × 40.6 cm
Private collection of
Jane and Bryan Gooch
Photograph: Roy Andersen

Mount Assiniboine, Stormy Sky, 1992
Studio oil 25.4 × 20.3 cm
Private collection
Photograph: Roy Andersen

Zelda Dawn, Mount Assiniboine, 1994
Studio oil 45.7 × 61.0 cm
Private collection of Hans Jintes
Photograph: Roy Andersen

JUSTIN JAMES MCCARTHY (JIMMY) SIMPSON (1877-1972)
Untitled (Moonlight on Mt. Assiniboine),
1941
Watercolour 30.4 × 22.8 cm
Collection of The Whyte Museum of
the Canadian Rockies. sij.05.43

Untitled (Mt. Assiniboine), 1945
Watercolour 32.0 × 24.0 cm
Collection of Num-Ti-Jah Lodge
Photograph: Roy Andersen

MIKE SVOB (1955-)
Glacier on Assiniboine, 2005
Oil on panel 30.5 × 40.6 cm
Private collection of the artist
Photograph: Mike Svob

The Towers, 2003
Oil on panel 30.5 × 40.6 cm
Private collection of Tim and Leslee Wake
Photograph:
www.insight-photography.com

MARY VAUX WALCOTT, (1860-1940)
Alpine Pointvetch (Oxytropis podocarpa),
1916
Watercolour on paper, life size on sheet
25.4 × 17.7 cm
Collection of Smithsonian American Art
Museum. 1970.355.619
Gift of the artist

Bearberry (Arctostaphylos uva-ursi), 1916
Watercolour on paper, life size on sheet
25.4 × 17.8 cm
Collection of Smithsonian American Art
Museum. 1970.355.449. Gift of the artist

Elkslip (Caltha leptosepala), 1916
Watercolour on paper, life size on sheet
25.4 × 17.8 cm

Collection of Smithsonian American Art
Museum. 1970.355.624
Gift of the artist

Moss Gentian (Gentiana prostrata), 1916
Watercolour on paper, life size on sheet
25.4 × 17.8 cm
Collection of Smithsonian American Art
Museum. 1970.355.516
Gift of the artist

White Globeflower (Trollius albiflorus),
1899
Watercolour on paper, life size on sheet
25.4 × 17.6 cm
Collection of Smithsonian American Art
Museum. 1970.355.690
Gift of the artist

CATHARINE ROBB WHYTE (1906-1979)
Mount Assiniboine, no date
Oil on canvas 22.8 × 27.8 cm
Collection of The Whyte Museum of
the Canadian Rockies
wyc.01.351

Near Assiniboine, no date
Oil on canvas 27.8 × 35.3 cm
Collection of The Whyte Museum of
the Canadian Rockies
wyc.01.135

Strom's Cabin, Mount Assiniboine, 1937
Oil on canvas 22.5 × 27.8 cm
Collection of The Whyte Museum of
the Canadian Rockies. wyc.01.185

PETER WHYTE (1905-1966)
Alpine Club Cabin, no date
Oil on canvas 27.6 × 35.0 cm
Collection of The Whyte Museum of
the Canadian Rockies. wyp.01.061

Magog and Sunburst Lake, no date
Oil on canvas 27.4 × 35.2 cm
Collection of The Whyte Museum of
the Canadian Rockies. wyp.01.217

Mount Assiniboine, September Snow,
no date
Oil on canvas 64.0 × 74.0 cm
Collection of The Whyte Museum of
the Canadian Rockies. wyp.02.09

Bibliography

Allen, S.E.S. "Mountaineering in the Canadian Rockies," *The Alpine Journal*, XVIII, 134 (November 1896), 222–236.

Allodi, Mary. *Canadian Watercolours and Drawings in the Royal Ontario Museum*. 2 vols. Toronto: Royal Ontario Museum, 1974.

"Alpine Climbing Canadian Pacific Rockies." *Resorts in the Canadian Pacific Rockies*. Canadian Pacific Railway, 1923, 13. Calgary: Glenbow Archives. Pamphlet 75.10.15/6.

Ashley, G.H.W. Letter to W.P. Morgan, Curator, Dunlop Art Gallery, June 15, 1981. Calgary: Glenbow Archives.

Barnes, Christine. *Great Lodges of the Canadian Rockies*. Bend, Oregon: W.W. West, 1999.

Beers, Don. *Banff-Assiniboine: A Beautiful World*. Calgary: Highline Publishing, 1993.

Benham, Gertrude. "The Ascent of Mt. Assiniboine," *Canadian Alpine Journal*, I, 1 (1907), 90–94.

Boulet, Roger. *The Tranquility and the Turbulence: The Life and Works of Walter J. Phillips*. Markham, Ontario: M.B. Loates Publishing, 1981.

Brennan, Brian. *Romancing the Rockies: Mountaineers, Missionaries, Marilyn, and More*. Calgary: Fifth House Ltd., 2005.

Brewster, F.O. 'Pat.' *Weathered Wood*[:] *Anecdotes and History of the Banff-Sunshine Area*. Banff: Crag and Canyon, 1977.

Carl Rungius[:] *Artist & Sportsman*. Companion to the Exhibit Organized by Glenbow Museum, 2000. Toronto: Warwick Publishing Inc., 2001.

Cavell, Edward. *Legacy in Ice*[:] *The Vaux Family and the Canadian Alps*. Banff: Whyte Foundation/ Distributed by Altitude Publishing, 1983.

Christensen, Lisa. *A Hiker's Guide to the Rocky Mountain Art of Lawren Harris*. Calgary: Fifth House Ltd., 2000.

Cole, Douglas, and Maria Tippett. *From Desolation To Splendour*[:] *Changing Perceptions to the British Columbia Landscape*. Toronto: Clarke, Irwin & Company Ltd., 1977.

———, eds. *Phillips In Print*[:] *The Selected Writings of Walter J. Phillips on Canadian Nature and Art*. Vol. 6 of The Manitoba Record Society Publications. Winnipeg: Manitoba Record Society, 1982.

Dowling, Phil. *The Mountaineers*[:] *Famous Climbers in Canada*. Edmonton: Hurtig Publishers, 1979.

Evenden, Kirstin. "Introduction,"

Carl Rungius[:] *Artist & Sportsman*. Companion to the Exhibit Organized by Glenbow Museum, 2000. Toronto: Warwick Publishing Inc., 2001.

Fenton, Terry. *A.C. Leighton and the Canadian Rockies*. Banff: Whyte Museum of the Canadian Rockies, 1989.

Fraser, Esther. *The Canadian Rockies*[:] *Early Travels and Explorations*. Edmonton: M.G. Hurtig Ltd., 1969.

Gest, Lillian. *History of Mount Assiniboine in the Canadian Rockies*. NP: np, 1979.

Gibbon, John Murray, ed. *Trail Riders Association of the Canadian Rockies Bulletins*. Montreal: Canadian Pacific Railway, 1926–1960.

Goldstrom, Marian, ed. *Fifty Years of Trails and Tales*. Calgary: Skyline Hikers of the Canadian Rockies, 1982.

Graff, Les. "Middleton." Pamphlet: Exhibition Notes and Biography. Edmonton, n.d.

Groves, Naomi Jackson. *A.Y.'s Canada*. Toronto: Clarke, Irwin & Co. Ltd., 1968.

Hart, E.J., ed. *Ain't it Hell*[:] *Bill Peyto's "Mountain Journal."* Banff: EJH Literary Enterprises, 1995.

———. *Diamond Hitch*[:] *The Pioneer Guides and Outfitters of Banff and Jasper*. Banff: EJH Literary Enterprises Ltd., 2001. (Originally published in 1979 by Summerthought Ltd.)

———. *Jimmy Simpson*[:] *Legend of the Rockies*. Canadian Rockies/ Vancouver: Altitude Publishing, 1991.

———. *The Selling of Canada*[:] *The CPR and the Beginnings of Canadian Tourism*. Banff: Altitude Publishing Ltd., 1983.

Harvie, Donald. "Foreword," *Carl Rungius*[:] *Artist & Sportsman*. Companion to the Exhibit Organized by Glenbow Museum, 2000. Toronto: Warwick Publishing Inc., 2001.

"Herb Ashley." Obituary. *The Banff Crag & Canyon*, Oct. 26, 2004.

Jackson, A.Y. "Artists in the Mountains," *The Canadian Forum*. V, 52 (January 1925), 112–114.

———. *A Painter's Country*. Toronto: Clarke, Irwin & Co. Ltd., 1964. First published 1958.

Joe Plaskett and His Paris – In Search of Time Past. Vancouver: University of British Columbia Fine Arts Gallery, 1971.

Leighton, A.C. Papers. Banff: Archives of The Whyte Museum of the Canadian Rockies. M214, 1276.

Lounsberry, Lorain. "Carl Rungius: Chronology," *Carl Rungius*[:] *Artist & Sportsman*. Companion to the Exhibit Organized by Glenbow Museum, 2000. Toronto: Warwick Publishing Inc., 2001.

"Magog Lake Camp," *Canadian Alpine Journal*, XXIII (1934–35), 118–119.

Oltmann, Ruth. *Lizzie Rummel* [:] *Baroness of the Canadian Rockies*. Calgary: Rocky Mountain Books, 1983.

Outram, James. "The First Ascent of Mt. Assiniboine," *The Alpine Journal*, XXI, 156 (May 1902), 102–114.

———. *In the Heart of the Canadian Rockies*. London and New York: The Macmillan Company, 1923. First published 1905.

Panabaker, Frank Shirley. Obituary. *The Globe and Mail* (February 20, 1992), A14.

Panabaker, Frank Shirley. *Reflected Lights*. Toronto: Ryerson Press, 1957.

Patton, Brian, compiler and editor. *Bear Tales from the Canadian Rockies*. Calgary: Fifth House Publishers, 1998.

———. *Tales from the Canadian Rockies*. Edmonton: Hurtig Publishers, 1984.

Plaskett, Joseph. *A Speaking Likeness*. Vancouver: Ronsdale Press Ltd., 1999.

Render, Lorne E. *A.C. Leighton*. Art Series No. 3. Calgary: Glenbow-Alberta Institute, 1971.

———. *The Mountains and the Sky*. Calgary: Glenbow-Alberta Institute, 1974.

———. "Rungius the Artist," *An Artist's View of Nature: Carl Rungius*. Edmonton: Provincial Museum and Archives of Alberta, 1969.

Renner, Barbara. *Mount Assiniboine Lodge Cook Book*. Banff and Calgary: Unicom Graphics Ltd., 1993.

"Report of the Assiniboine Camp, 1920," *Canadian Alpine Journal*, XII (1921–22), 195–197.

Resorts in the Rockies Canadian Pacific Railway, 1924. Calgary: Glenbow Archives. Pamphlet 971.18 R68 3rst.

Rummel, Elizabeth. Sunburst Lake Camp Guestbooks, 1951–70. Banff: Archives of The Whyte Museum of the Canadian Rockies. M28 40.

Sandford, R.W. *The Canadian Alps–The History of Mountaineering in Canada*. Vol. 1. Banff: Altitude Publishing, 1990.

———. *Once Upon a Mountain* [:] *The Legend of the Grizzly Group*. Canmore: The Alpine Club of Canada and McAra Printing, 2002.

———. *Trail Riders of the Canadian Rockies* [:] *75th Anniversary 1923–1998*. Canmore: The Alpine Club of Canada and McAra Printing, 1998.

Scott, Duncan Campbell. *Walter J. Phillips*. Toronto: The Ryerson Press, 1947.

Simpson, James. "Days Remembered," *American Alpine Journal*, XIX, 1(1974), 43–54.

Smith, Cyndi. *Off The Beaten Track* [:] *Women Adventurers and Mountaineers in Western Canada*. Canmore: Coyote Books, 1989.

Strom, Erling. "Mount Assiniboine History," *The Assiniboine Wrangler*, 6 (December 1955), 4. In Strom Papers. Banff: Archives of The Whyte Museum of the Canadian Rockies. M110.4.

———. *Pioneers on Skis*. Central Valley, New York: Smith Clove Press, 1977.

Tetarenko, Lorne, and Kim Tetarenko. *Ken Jones* [:] *Mountain Man*. Calgary: Rocky Mountain Books, 1996.

Trono, Lewis. "Herb Ashley's talent legendary." *The Banff Crag & Canyon*, July 11, 2001.

Vaux, Mary M. "Camping in the Canadian Rockies," *Canadian Alpine Journal*, I, 1 (1907), 67–70.

Walcott, Mary Vaux. *North American Wild Flowers*. Washington, D.C.: Smithsonian Institution, 1925.

Webster, Donald Blake. "Foreward," *Canadian Watercolours and Drawings in the Royal Ontario Museum*, 2 vols. Toronto: Royal Ontario Museum, 1974.

Wheeler, A.O. "Banff to Mt. Assiniboine via Spray Lakes Route," *Canadian Alpine Journal*, XI (1920), 234–235.

Whyte, Catharine. Letters. Banff: Archives of The Whyte Museum of the Canadian Rockies. M36 102.

Whyte, Jon. *Mountain Glory* [:] *The Art of Peter and Catharine Whyte*. Banff: Whyte Museum of the Canadian Rockies, 1988.

Whyte, Jon, and E.J. Hart. *Carl Rungius: Painter of the Western Wilderness*. Vancouver: Douglas & McIntyre, 1985.

Wilcox, Walter D. *Camping in the Canadian Rockies*. 2nd edition with map. New York and London: G.P. Putnam's Sons, The Knickerbocker Press, 1897.

———. "An Early Attempt to Climb Mt. Assiniboine," *Canadian Alpine Journal*, II (1909–10), 10–25.

———. *The Rockies of Canada*. A Revised and Enlarged Edition of *Camping in the Canadian Rockies*. 3rd edition. New York and London: G.P. Putnam's Sons, The Knickerbocker Press, 1909.

Wonders, Karen. "Big Game Hunting and the Birth of Wildlife Art," *Carl Rungius* [:] *Artist & Sportsman*. Companion to the Exhibit Organized by Glenbow Museum, 2000. Toronto: Warwick Publishing Inc., 2001.

"Zelda Faye Nelson," *International Artist*, 37 (June/July 2004), 117.

Zimon, Kathy E. *Alberta Society of Artists* [:] *The First Seventy Years*. Calgary: University of Calgary Press, 2000.

Index

JANE GOOCH's most recent visit to Mount Assiniboine was in August 2007 when she and her younger son hiked in from Sunshine Meadows over Citadel Pass and through the Valley of the Rocks, following in the footsteps of early explorers such as Wilcox and Peyto. Like them, Jane has felt drawn toward the alluring peak of Assiniboine, and for many summers she has journeyed to the Rockies from her home in Vancouver. Her winters are taken up with teaching English at the University of British Columbia. Jane is also a UBC graduate, and holds a doctorate in Renaissance drama from the University of Toronto. Her enduring interest in visual art and her great love of hiking have inspired her to examine the art of special places in the mountains. She is also an amateur artist who has the greatest admiration for those gifted individuals who can capture the changing lights and moods of the alpine landscape. Jane Gooch's earlier book *Artists of the Rockies: Inspiration of Lake O'Hara* illustrates and describes 100 years of artistic activity at Lake O'Hara in Yoho National Park; it was published in 2003 by The Rockies Network of Fernie, B.C. and by the Alpine Club of Canada.